THE ESSENTIAL IMAGE

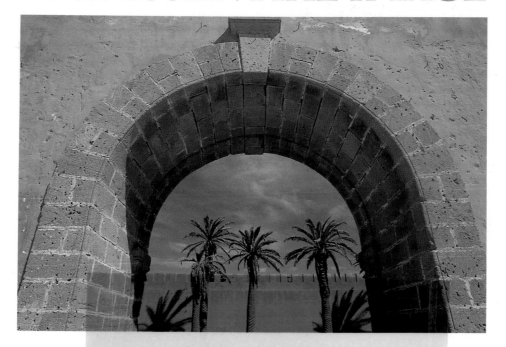

Lisl Dennis

THE ESSENTIAL IMAGE

AMPHOTO
An Imprint of Watson-Guptill Publications
New York

Special thanks go to my editors at AMPHOTO: to Michael O'Conner who originally conceived the idea for this book; to Marisa Bulzone for her patient support; and to Susan Hall for her ultimatum. I also want to thank Air India, British Air, Lufthansa, and Royal Air Jamaica. This book was written at the Virginia Center for the Creative Arts in Sweet Briar, Virginia. Thank you, Bill Smart, for providing the place where my books are born.

Designed by Jay Anning
Graphic production by Ellen Greene

First published 1989 in New York by AMPHOTO,
an imprint of Watson-Guptill Publications,
a division of Billboard Publications, Inc.,
1515 Broadway, New York, NY 10036.

Library of Congress Cataloging-in-Publication Data
Dennis, Lisl.
 The essential image.
 Includes index.
 1. Photography. I. Title
TR145.D43 1988 770 88-33777
ISBN 0-8174-3932-3
ISBN 0-8174-3933-1 (pbk.)

Manufactured in Japan

1 2 3 4 5 6 7 8 9 / 95 94 93 92 91 90 89

To Landt Dennis

CONTENTS

INTRODUCTION

Every photographic encounter is a potential revelation, a moment when the very essence of an object or a scene or a person is recognized. The very act of stopping to click the shutter means that we've seen to some extent the essential nature of the subject we are looking at. If this were not the case, we would not only bypass a particular subject, we might not even see it at all.

It may be easy to accept the idea that our photographic images are the result of a deep desire to perceive the essential nature of people, places, and things, and to manifest them on film. More difficult to acknowledge is the fact that the photographic process is also capable of revealing our *own* essential nature as we relate to the world. We stop to take a picture when our awareness of the external physical world and our personal interior world coincide. This moment of revelation can be a thrilling, deepening experience.

The practical realities that bring us to this exhilarating moment are what this book is about. In each case, I have selected an example to explore how best to use color and composition and how to choose the most appropriate format. I discuss abstraction and angles, and describe how color affects composition. It is the confluence of all these elements that leads the photographer to the most graphic and dramatic picture.

As we go from one visual revelation to another, our ability to visualize graphically grows more acute and our images become more clearly defined. If photographic refinement is a goal, making our personal processes more conscious is essential. Aristotle, who must have been a great visual thinker, went to the heart of the matter when he said, "The soul never thinks without an image."

If we desire to express positive qualities in our photographs and give them more graphic impact, we must come to grips with the concept that images are a projection of our souls, as Aristotle believed. In other words, we see what we think and we see what we are. To this extent, all photographs are self-portraits. This is why different photographers shooting the same subject will produce many varied, personal interpretations of that subject.

Graphic visualization in photography is heightened by intellectual and spiritual refinement, not by graphic design rules and regulations, a few of which I discuss here. I have also refrained from offering a litany of lens-use rules.

The idea that our images are projections of subjective reality isn't new. I don't claim to have invented it, nor did I adopt it as part of the New Age rhetoric. Through my own photographic experience around the world for more than twenty years, this concept has become as real to me as ISO ratings or filter factors. And when I use it to my advantage, it works. On such a good day, I find that visualization abilities quicken and inspiration kicks in to cue me on the technical and aesthetic treatment of subjects. The chemistry of aspiration and aliveness are what infuse one's work with power and individuality. It is then that the photographer and the subject are one. It is then, too, that one loses all sense of anxiety about whether the world out there will provide photo opportunities, and gains, instead, the trust to know that pictures are indeed within and often transcend the subject matter.

I will stick with photography as long as I keep learning from my photographic encounters. The process of photography means far more to me than the pictures I take. The most valuable images are the graphic memories that the photographs induce. So long as I have an occasional revelation behind the camera, I will happily accept my invitations to the world's visual feasts.

A Case-Study Approach

While driving along a highway on Guadeloupe in the French West Indies, I was lured off at an exit by a blue and pink graphic on a wooden building. As I pulled up to it, I saw a Guinness sign telling me that the colorful island building was a bar not yet open. I parked and proceeded to take photographs, isolating the graphic elements that had caught my attention when I was driving at 90 kilometers an hour.

What I had seen from the highway was a complete image: the road in front of the bar, the people, and the surroundings. For some photographers, this overall descriptive rendition of the situation would be the whole picture. For me, it is merely a contextual recording of a place with graphic potential. At the Guadeloupe building, I composed a photograph that isolated the relationship of color, line, and shape on the building's façade. From this intimate point of view with its graphic detail, we know more quickly that this is a bar. The Guinness sign is more accessible, and the impact of the island color scheme is more direct.

Using this case-study approach, I will discuss graphic visualization as I experience it, by first showing an overall contextual shot and then sharing the creative thought processes and impulses behind each photograph.

The overall shots are not resolved photographs, acceptable pictures that I then make much better. They are shown only for their contextual information. I have discovered in my workshops that this technique is of enormous help to photographers, who are eager to increase their own visualization abilities and appreciate seeing finished photographs. However, they can only critique them from the standpoint of backseat drivers who are unable to see the bumps in the road. As a teaching tool, the finished image is limited because it is an abstraction from reality: viewers have no frame of reference and no way to determine if they would take the same picture, the same way, or not. While the contextual shots in this book are limited by their singular point of view and do not give viewers the three-dimensional familiarity with each situation available to the photographer on the scene, they do give at least some idea of my photographic context.

My choice of subject matter reflects my travels in recent years. That the images in the book seem to be graphic travel photographs is not coincidental. However, this is not a book about travel photography or how to take better travel photographs. By transcending subject matter, I hope to convey ideas and feelings that will help photographers, both amateurs and professionals, discover what fuels their photographic impulses and, specifically, how they can imbue their work with greater graphic qualities.

An investigator is a special sort of "seer", one who sets out to search or to examine, and to do so with careful inquiry. I set the "investigator" in me to work by doing all I can to be open to ideas on all levels, by taking my time with those ideas, and by approaching them with care. Throughout this book I will tackle, one by one, the blocks to such openness, and order some techniques for getting rid of them.

The first of those blocks is our lack of faith in our own intuition, that trigger-quick instinct that can whirl us around and perhaps send us charging through traffic and instruct the finger to click the shutter.

Anything that closes us off from that gut response, whether it is rationality, cultural closemindedness, cynicism, fear, or a pure and simple lack of knowledge of self, is the enemy of our vision.

Our minds must be as open as our shutters, for it is through them both that revelation appears. Ironically, in this art form of clarity and focus, our dreams, memories, and the flotsam and jetsam of our lives play an enormous role. They must be trusted or our photographs will not reach others on these deep, compelling levels.

We have all seen working photographers in comic, sometimes grotesque poses, intent on capturing an elusive subject that is seen for the first time. Those photographers are in their own worlds so they can give a message to ours. They aren't merely "seeing"; they are investigating, listening to nothing but the still, small voice saying, "Now!"

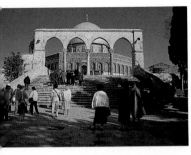

Optical Fluency

The first technical photographic challenge is to develop optical fluency, a familiarity with a wide range of lenses and the graphic effects they make possible.

Investigating single subjects with various focal lengths, as I did here at the Dome of the Rock in Jerusalem, helps the photographer to develop optical fluency. With experience comes the ability to know instinctively, without experimentation, the effect of a given lens.

There will be more discussion of optics throughout this book, but I want to establish at the outset that, by explaining my own lens choices, I wish to encourage you to undertake your own optical investigations. Because different photographers never take exactly the same pictures, we must discover our own optical balances and approaches to the subjects that interest us.

The two men chatting attracted me to the first picture I made at the Dome of the Rock in Jerusalem. Using a 28–50mm zoom lens, I took this shot at approximately 50mm from part way up the stairs.

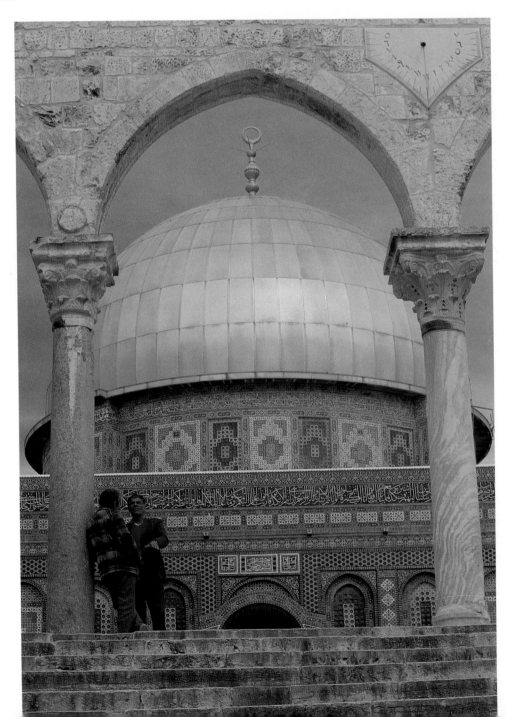

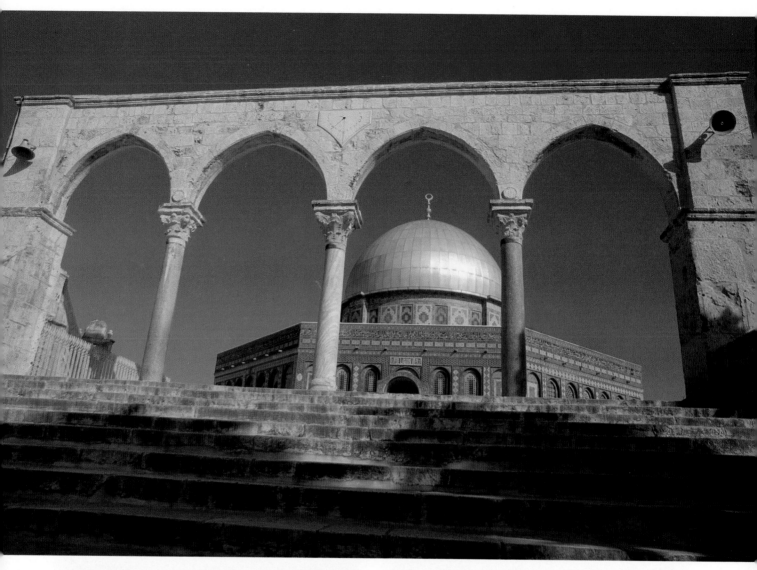

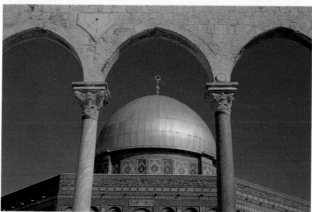
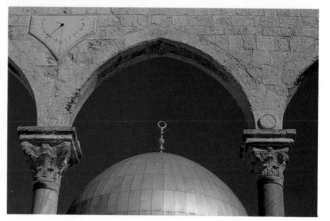

Because there were four arches, I couldn't center the Dome of the Rock underneath one of them. Moving over to the right, I accepted the distortion of a 24mm lens as inevitable. Switching to an 80–200mm zoom lens, I made three compositions emphasizing the Dome. My favorite is the tight detail that concentrates on the graphic impact of the glowing gold and mosaic.

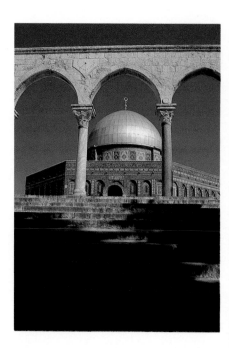

Here I used a tripod and an 80–200mm zoom lens at 200mm to emphasize the relationship between the glistening dome and the patterns of the mosaic. When I began photographing the dome, I knew I would end up with this shot, which distills the essential graphic qualities of the mosque.

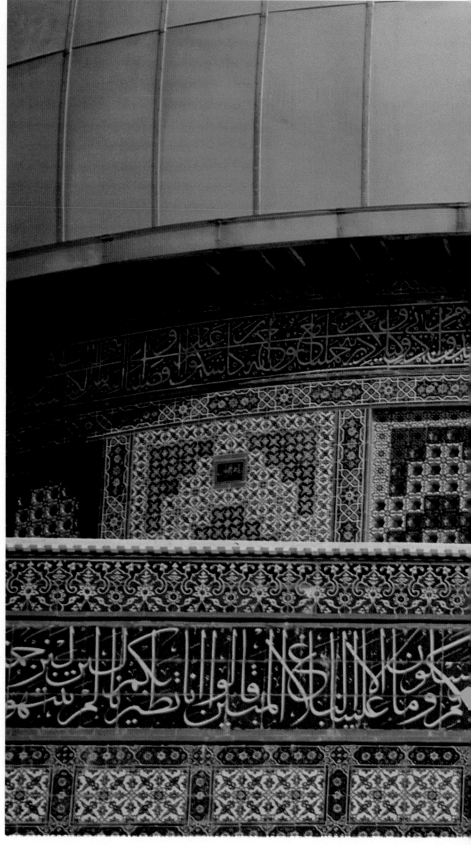

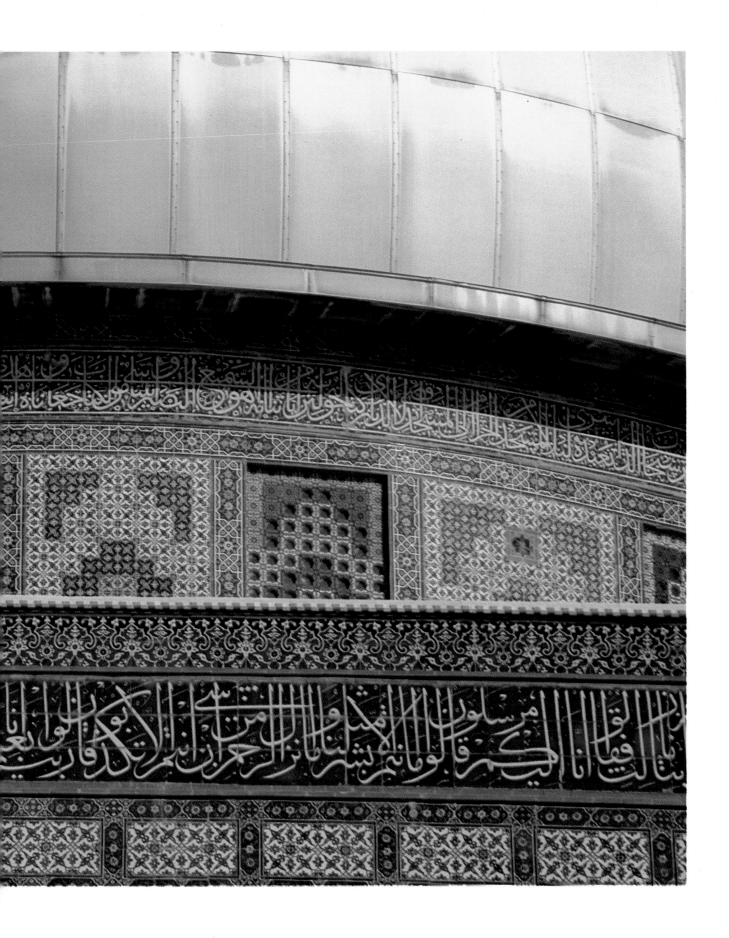

Becoming Curious

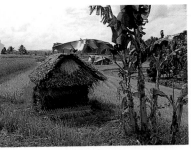

It is our curiosity that will lead us around corners, through doors, behind walls, and into Balinese thatched huts, that will take us beyond the safe, surface visual experience. These Indonesian rice fields alternated their yellow rows of ripe grain with green grass, undulated as I drove by, and converged before me on the horizon. Despite the graphic potential here, there was no focal point in the fields, no workers punctuating the rows, for instance. The overcast day flattening the stripes didn't help, either. Then a charming thatched work hut came into view. Wondering if I could pull some graphics out of this less-than-ideal situation and curious to know what was in the hut, I stopped the car. With my first step into the field, I sank in, ankle deep, and had to abandon my shoes. With my curiosity leading me to slog on, I made these photographs, reflecting my enriched textural experience, both inside and outside the hut.

To me, a wide-angle lens calls for optical intimacy, not for standing back to get it all in. The inherent distortion of a 20mm lens enabled me to do both, however. On Bali, I moved in quite close on the side of a little grass shack and was able to include the rows of yellow grain and green grass beyond. Then, I moved in for an ultra-intimate detail of the thatch on the shack, taken from about 3 feet away. The optical distortion of the 20mm lens spreads the subject across the film plane, making you feel as if you could touch the thatch. The same composition taken with a longer lens would have rendered a less intimate "over there" effect, which I don't think would have had as much graphic impact.

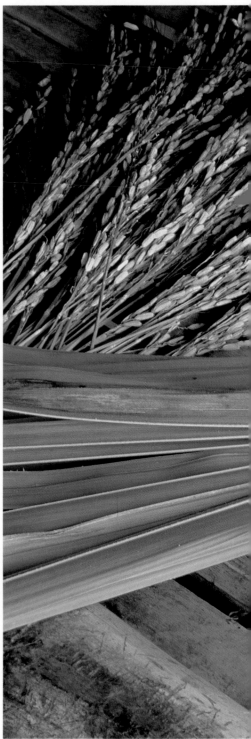

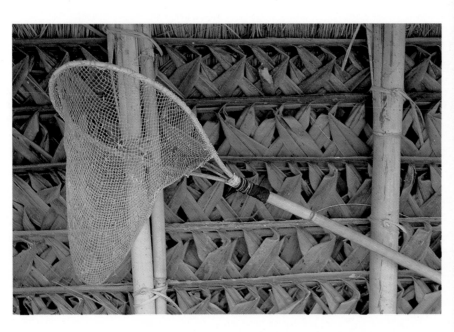

Inside the field worker's shack, I discovered a fishing net hanging in the bamboo rafters. Its shape and texture appealed to me against the woven thatched ceiling. Using a tripod and a 60mm macro lens, I checked through the viewfinder, then adjusted the net to make sure the bamboo beam intersected the net without interfering with its shape too much. I use a fixed-focal-length macro for all kinds of photographs, including landscapes, closeup portraits, architecture, and still lifes, as well as for true macro details.

Again using a 60mm macro lens, I made a still life of a basket and bundles of grass and rice. But I felt something was missing. From under the table, I excavated a sickle, which was just the element I needed to complete a still-life interpretation of the rice harvest. To keep the Balinese gods appeased for my reordering of the Indonesian universe, I returned all props to the original position where I had found them.

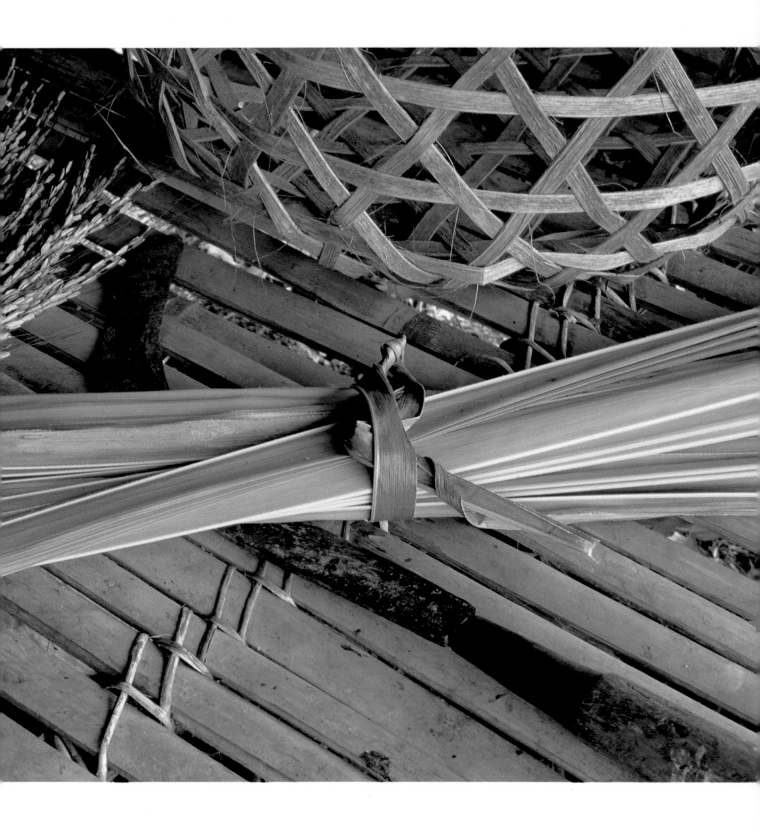

Taking Time

When we are traveling, we tend to rush, to take less than the time needed to investigate a subject of photographic interest. There is so much more to see down the road. The bus is waiting. Or our spouse is bored with our picture taking. However, if developing a graphic sensibility is truly a top priority, we must work out ways to spend more time with subjects.

I did not rush through the 18th century Church of San Geronimo outside Oaxaca, Mexico. I spent several hours working there. Under Spanish supervision, the Indians had painted the church walls with spectacular Baroque floral motifs, and it took time for one artist to savor—and capture—the artistry of others.

For me, developing a series of images on a single subject or theme is more satisfying than taking single, unrelated pictures. It's the *feel* of a place that is important to get on film, not only the *fact*, and taking time stimulates my interpretive capability. A certain amount of "marination" in the subject is necessary for this to happen.

Exploring the inner utility sanctum of a Spanish Colonial church in Mexico, I photographed a processional Jesus figure and plastic brooms. Using a tripod and fill flash through a diffusion umbrella, I made a photograph, the first in a series I took in the church. Using the same lighting treatment on all shots, I metered for the existing light, which indicated 1 sec. at *f*/4. Syncing the flash at 1 second, I made three exposures: at *f*/4, *f*/5.6, and *f*/8. By syncing a flash at the metered shutter speed and stopping down, you eliminate the harsh shadows normally attributed to flash photos synced at 1/60 sec.

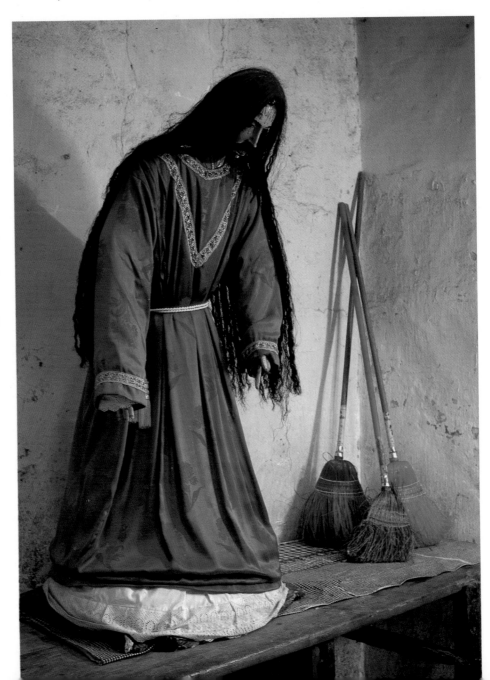

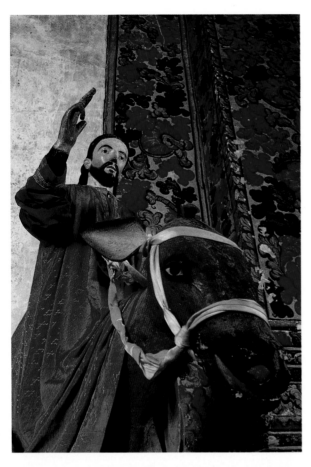

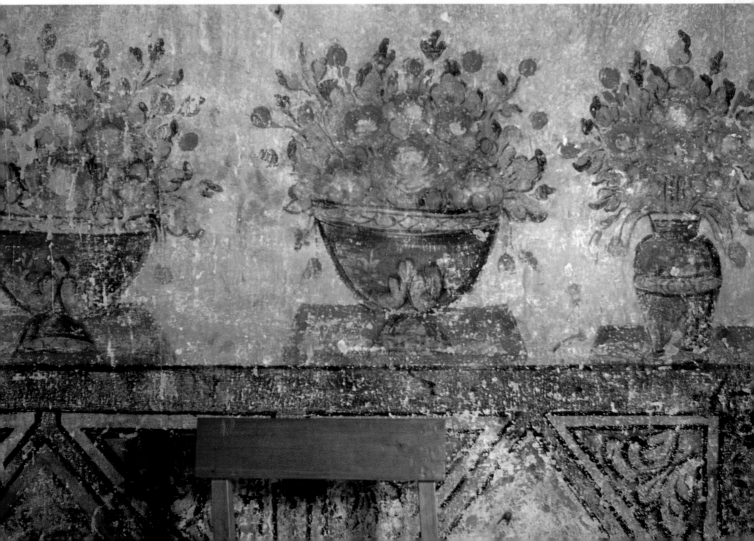

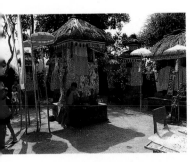

Beyond the Obvious

With the Indonesian festival shrines, I was first drawn to the two red umbrellas, the most obvious initial attraction. Next, the boys caught my fancy. Finally, I recognized the graphic possibilities of the shrine decorations. These illustrations represent my natural progression from obvious to more subtle images. You can see how the red umbrellas popped out at me. Then, as I worked with the boys, I noticed the woven reed and painted cloth streamers emerging from the shrine openings. I investigated a number of these colorfully graphic images and became temporarily absorbed in them.

Until I've exhausted a subject or idea, I block out other photographic temptations, feeling that the acquisitive anxiety—the desire to make all possible shots—inherent to photography must sometimes be suppressed. The initial, more obvious photographs, while no less valid, turned out to be merely a visual warm-up, preparing me to be receptive to the images that were finally to emerge.

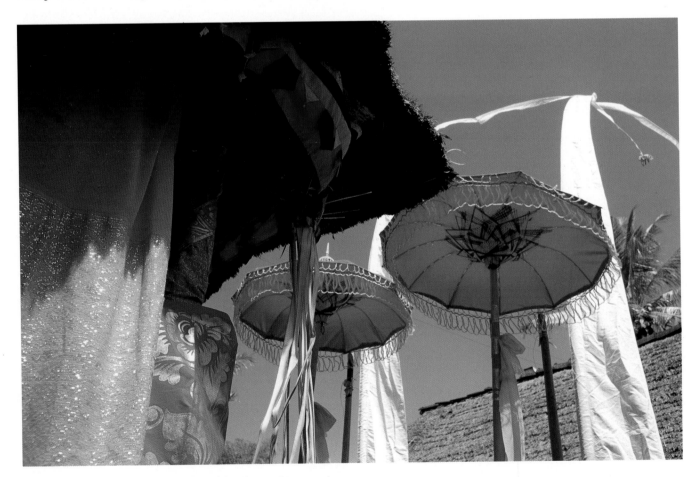

Sometimes I know my first shot of a subject is no winner, and may not even be a keeper. It may be a mere warm-up exercise. Such was the case upon entering a private family shrine on Bali.

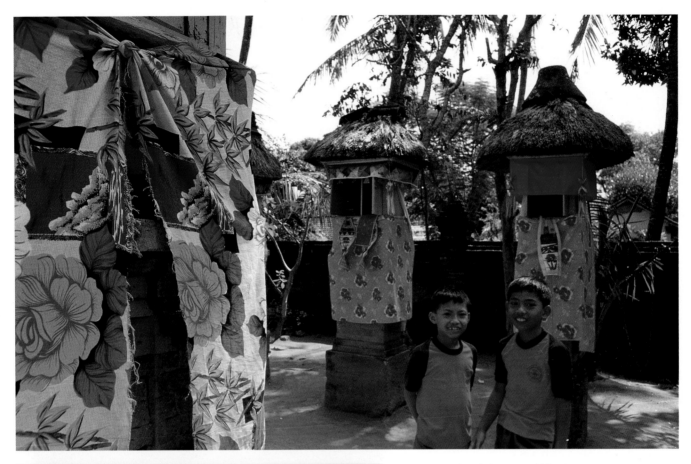

Knowing the shrines would look confused against the background, I purposely grounded the composition with a strongly colorful left side. The boys were a serendipitous addition. The vertical portrait of the boys is nice, but the empty black opening of the shrine is definitely a problem.

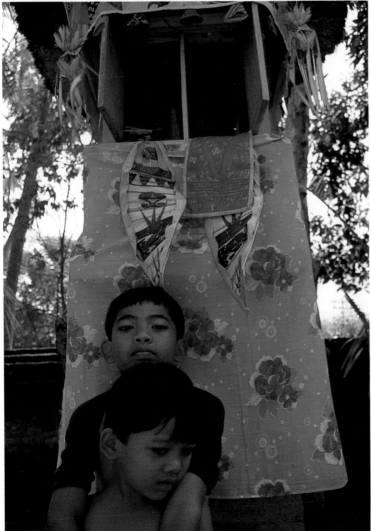

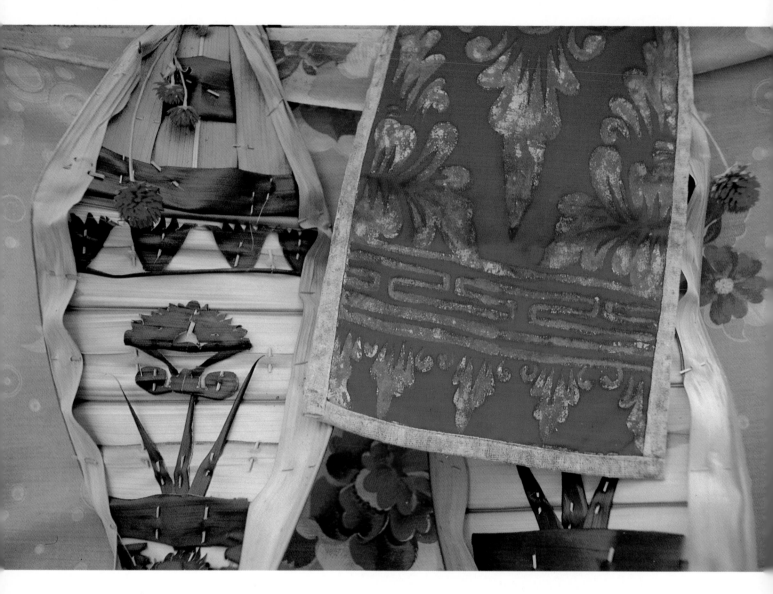

After struggling with the overall shots of the shrine area and not being satisfied, I finally zeroed in on the fabric-and-reed streamers that dripped from the shrine openings. The intense color and the natural materials used for decorations are typically Indonesian. These graphic details are as valid cultural statements as a more generic landscape shot of terraced rice fields: All express both man-made and natural Indonesian design.

Visual Seduction

Cultural disorientation sometimes blocks our response to unfamiliar and curious sights, especially in third world countries, where, without realizing it, we shut out images having no relevance to our cultural experience.

A red fabric wrapped around a tree in Thailand, for instance, may have no correlative for Westerners. Not consciously knowing that it's there to keep evil spirits away, we feel no intellectual justification to photograph the fabric, disregarding the fact that we may have responded to it on a visceral level. We would do well to reverse this impulse, to instead allow ourselves to be visually seduced by culturally peculiar symbols and manifestations.

In Egypt, I wandered into a tent where gilded chairs were covered with ghostlike bags, each one bearing a unique personality and mysterious form. My having known about an impending funeral or political rally wouldn't have enhanced my pleasure in taking the photographs. Far from meaning this as an argument for international ignorance, I suggest we train ourselves to give in to the seductions of the unfamiliar, in pursuit of the spontaneous, intuitive photograph.

What is it? I don't care! If a subject has graphic potential, I'll dive right in with my camera. What appealed to me here was the relationship between the Arabic script on the chair covers and the colorful Egyptian tent. The repetition of the off-white in the flower design ties the two elements together.

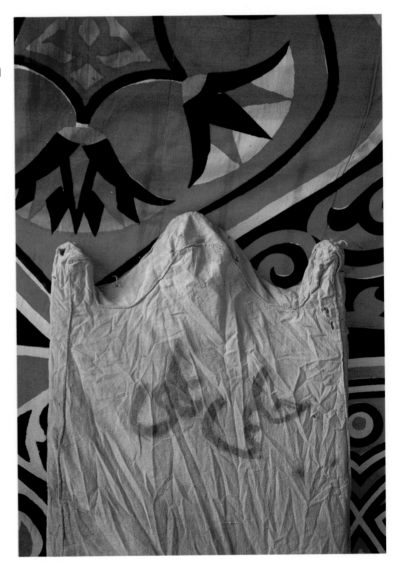

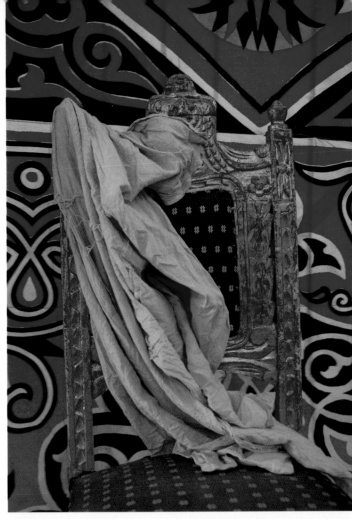

The gilded chairs in various states of dress and undress made curious studies of texture, color, and design. The chairs take on personality in their ghostlike protective bags. My favorite shot is of the loose-fitting bag flopped over the chair top.

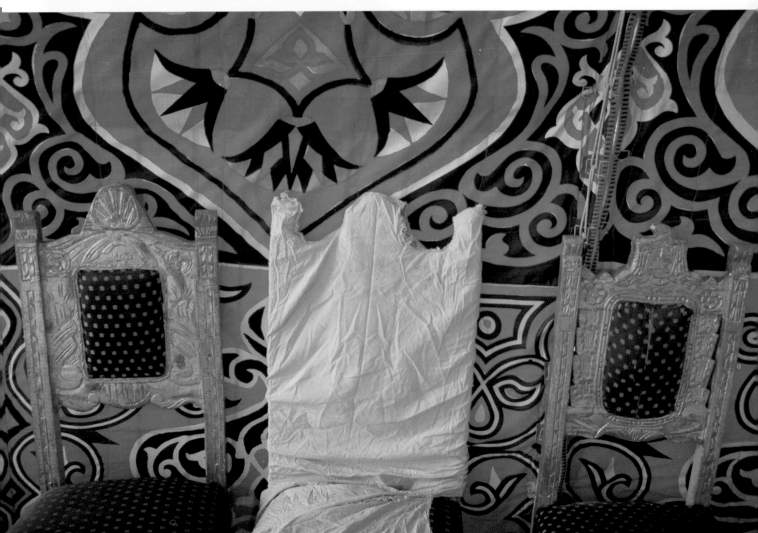

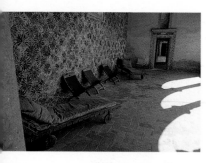

Frame of Reference

Our social, intellectual, and educational frames of reference serve to color and inform our photographic responses to the world. Images that make an impression on us linger in our memory and can trigger our artistically necessary investigations into our subjects.

In Portugal, I visited an estate owned by Portuguese aristocrats. The pool house had original 18th century tiles and sling-backed chairs, which had been recently recanvased. But the moldy, old, chartreuse chaise lounges appealed to me the most.

Subconsciously I was reminded that, as a child, I had kicked osage oranges down dirt roads. They were the yellow-green color of this vintage fabric, a color also very popular with interior decorators of the 30's and 40's. Granny's wing chair might well have had ill-fitting chartreuse slipcovers. These nostalgic references, coupled with an appreciation of Portuguese social heritage, fueled my photographic investigation of the pool house. It is just such personal interaction that intensifies the photographic experience.

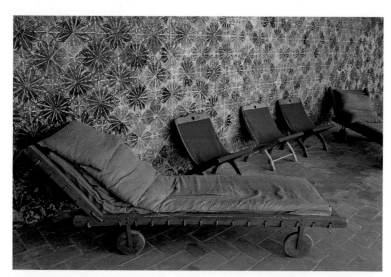

For the first shot of a pool house at a Portuguese villa, I included all the furniture. I arranged things a bit to accentuate the long lines of the chaise lounge in the foreground. And I carefully spaced the sling-backed chairs.

After the overall shot, I made tighter compositions that concentrated on the color and graphic impact of chairs and chaise lounge as they related to the beautiful Portuguese tile, evocative of ages past.

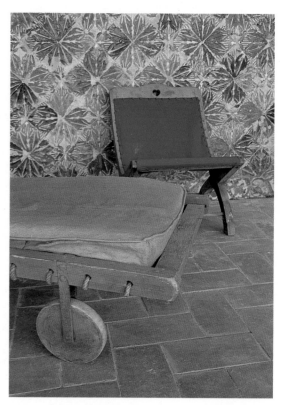

Stream of Consciousness

As streamers and confetti were being swept up at the Venice Winter Carnival, a colorful snarl of paper spaghetti against a column caught my eye. Though I took a vertical shot, there was not really enough interest in the column to make an effective photograph. But that investigation placed the streamers into my consciousness; no longer did I take them for granted as a symbol of the festivities.

Now caught up in my subject, I bought a roll of my own streamers and festooned the city's mascot, the Lion of Venice, with them, capturing a conceptual illustration of the carnival. As I wandered the streets, I became aware of many weird and wonderful ways to photograph the streamers. On a windy afternoon, a clump of streamers was stuck in the wall of a classical building, providing me with a surreal image. Even more surreal is my "Death in Venice" picture of a dead pigeon entwined in streamers, which reflects the dark side of the carnival experience.

At the Venice Winter Carnival, I accepted trash as viable subject matter for photographs. Streamers and confetti were the flotsam and jetsam of a hell of a good time. But they turned out to be hell to photograph as a symbol of the event. In this photograph, the column base doesn't have enough sculptural or color interest as an environment for the paper products. It doesn't say, "Venice".

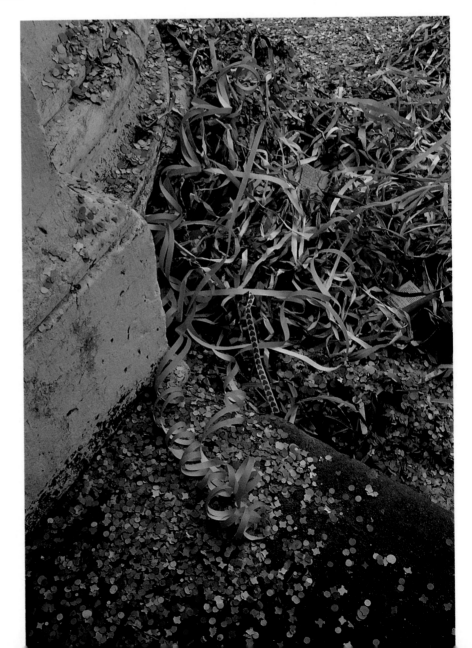

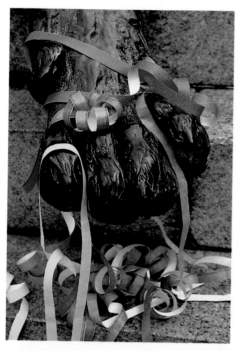

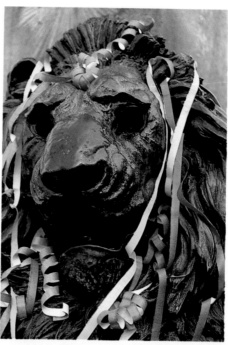

Decorating the Lion of Venice with streamers attracted a lot of copycat shooters. The idea solved my problem of how to photograph the streamers and convey a sense of place. However, no one followed me up on my picture of a dead pigeon tangled in streamers. Merrymakers were spellbound watching me record a surreal clump of streamers flowing from a crack in a classic Venetian wall (following spread).

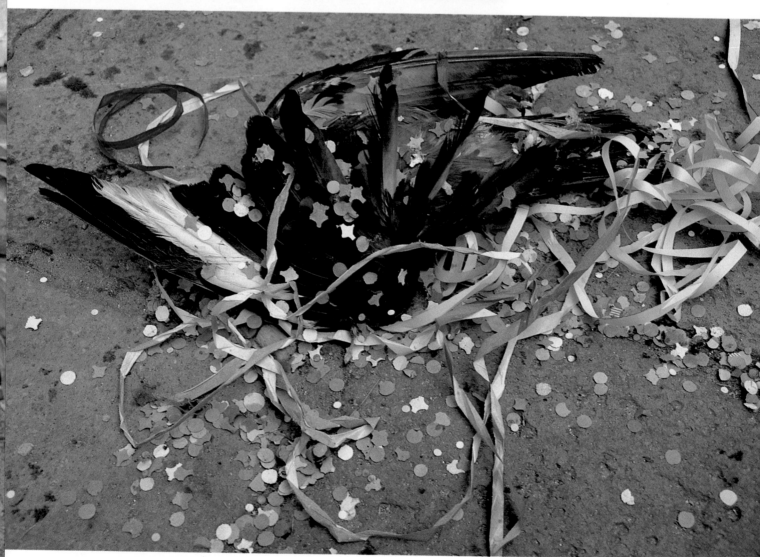

CHOOSING A FORMAT

There are two formats for working with a 35mm camera: horizontal and vertical. The horizontal format seems to be a more automatic choice, probably because a camera is easier to hold in the horizontal position. What many photographers overlook, however, is that the two formats have a different impact on composition: Vertical pictures encourage the eye to move up or down in the frame, whereas the eye tends to move from side to side in horizontals.

The horizontal format is good for emphasizing the horizon, or horizontal lines and shapes. A feeling of groundedness and stability is inherent in the way visual weight is distributed across a horizontal picture, making this the best format for evoking a feeling of peace or tranquility.

Developing a dramatic sense of depth—or contrasting what is below with what is above—is easier to do in a vertical format, where the eye must break away from gravity to travel up and down in the frame. This gives a vertical composition a more dynamic charge. Picture editors, incidentally, generally prefer to use verticals on magazine and book covers, because most publications have vertical formats.

There is no "right" format—it always depends on the picture situation at hand and what you feel is important in it. If both formats seem to work equally well, shoot the picture both ways; later on you can decide which one you like best. Using a little extra film is worth the price of not missing a one-time picture opportunity.

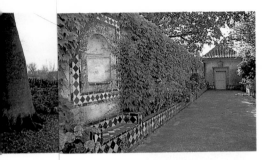

Works Both Ways

In both the natural and man-made environment, the aware observer will find that the world is full of graphic order. We simply need to recognize this order to frame it in our viewfinders. In Portugal, I saw that blue tile symmetrically set into a garden wall was asymmetrically festooned with ivy. The superstructure of the two images is the tile, the dominant graphic element, despite the fact that it's covered by the ivy. In both images you'll notice that the composition naturally assumed the rule of thirds. For this reason, both horizontal and vertical formats are successful.

We must not try to jam the world into compositional formulas. But when it becomes obvious that forms will dynamically organize themselves into thirds, there is no reason to fight it. To do so is to take a self-conscious stance that is contrary to nature, resulting in forced imagery.... or just bad pictures.

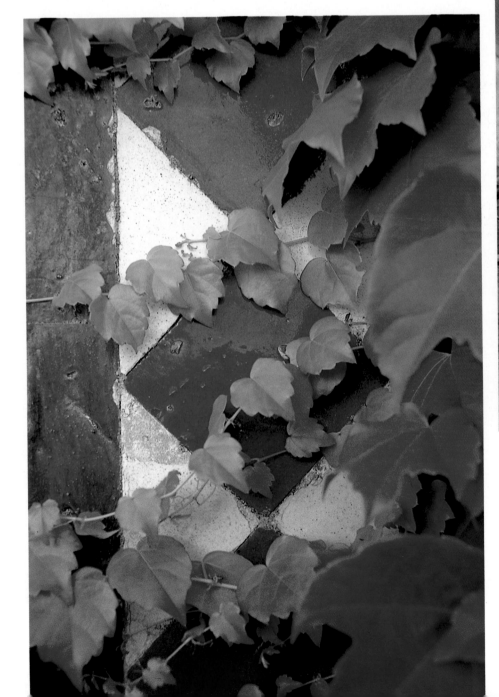

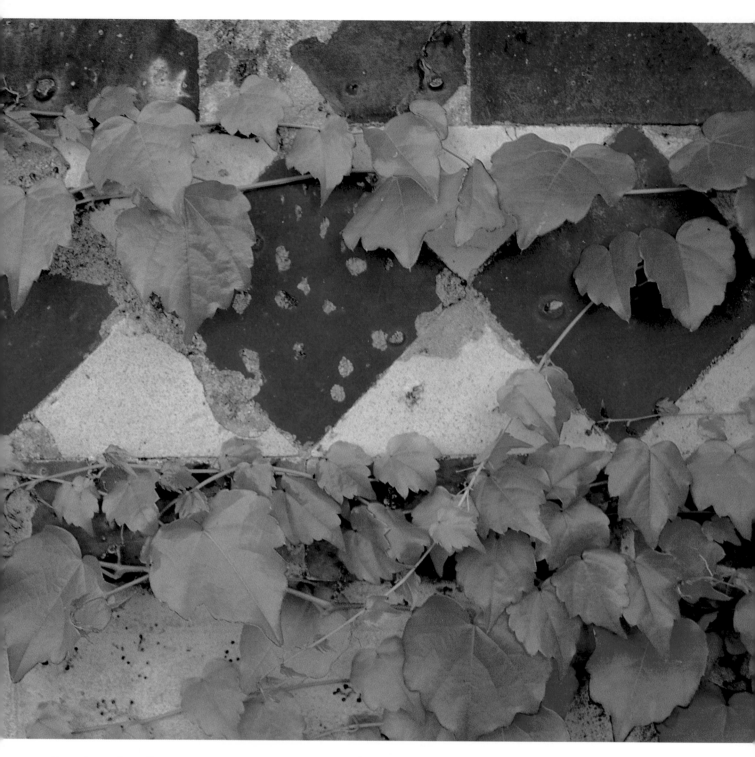

Sometimes when I first see my slides, I am astonished by my subconscious attractions. The appealing shine on both the Portuguese tiles and the leaves did not catch my conscious attention as I was taking these photographs. I wonder to what extent these subtle attractions subconsciously govern our choice of subjects, as well as format.

While both formats have merit, I think the chipped tile in the horizontal conveys a greater sense of antiquity. This is an important observation because it was the patina of Portugal's past that attracted me to the tiles in the first place.

Feeling the Format

The most satisfying way to determine the right format for a photograph is to simply "feel" your way through the viewfinder in a visual free association.

In Thailand, a black water pot sat next to a Buddhist monk's saffron-colored robes that were hanging out to dry. By placing the pot on the railing, I immediately made the vertical format photograph possible. Then, for comparison, I shot a horizontal.

I feel the dynamics of the round black shape against the vibrant color are more pronounced in the vertical, making it the superior format. Notice that the diamond shadows in the railing provide a strong base for the dominant pot, and that the pot is dead center in the composition, an alleged taboo. Some photographers might prefer the greater sensory effects of the fabric in the horizontal. But I think the vertical is the better image.

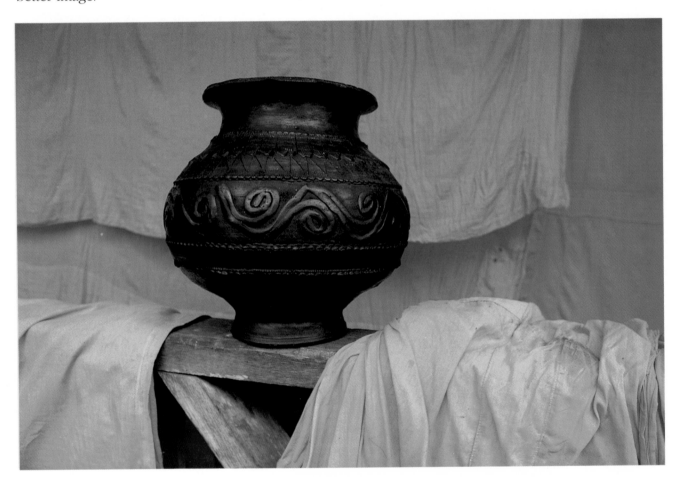

Black is a color I've always been drawn to, especially in contrast to high-key hues. You can get away with the most alarming color combinations if there is a black element somewhere in the composition as a counterpoint.

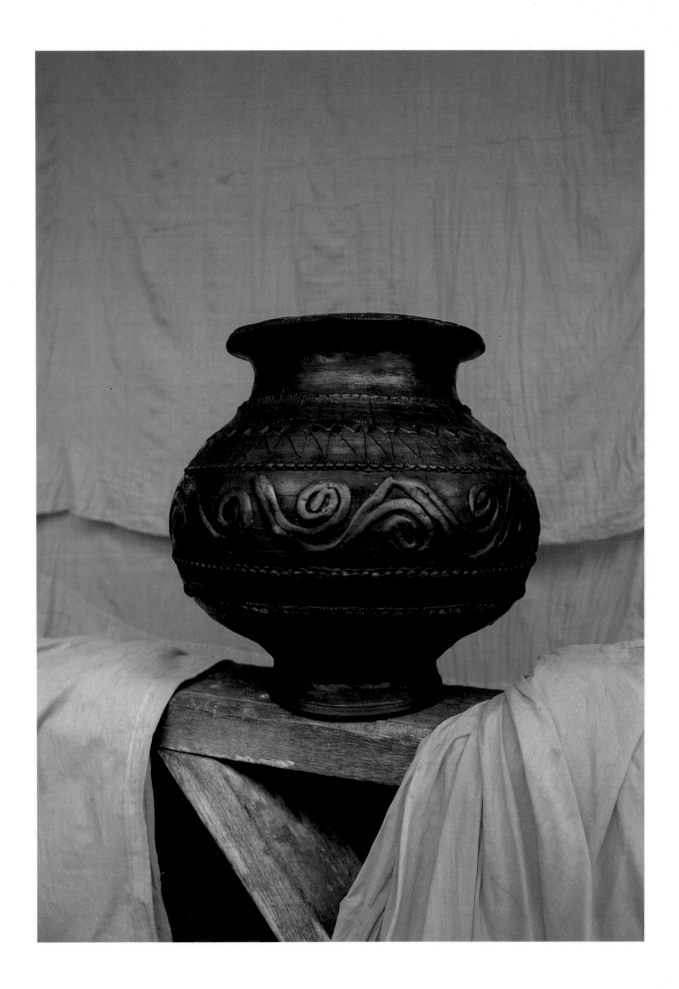

"Hearing" the Format

Just as in feeling the format, the process of "listening" for cues to the right format has much to do with blocking extraneous environmental interferences. We are continually being told by the conscious and unconscious mind how to handle both the technical and creative aspects of a photograph, but in order to hear we have to be listening for the cues. If it's impractical or unsafe to totally block environmental static, we must learn to cope with it better than I did on one of my India tours, when I was preoccupied with the possibility of photographers being run over as they stood in the street photographing these decorated bullocks. By the time the coast was sufficiently clear for me to grab my shots, I was so rattled and pressed for time that I did not hear the "vertical" message given me. Tour participant Jane Walton certainly did. Her photograph on the right is far superior to my horizontal attempt.

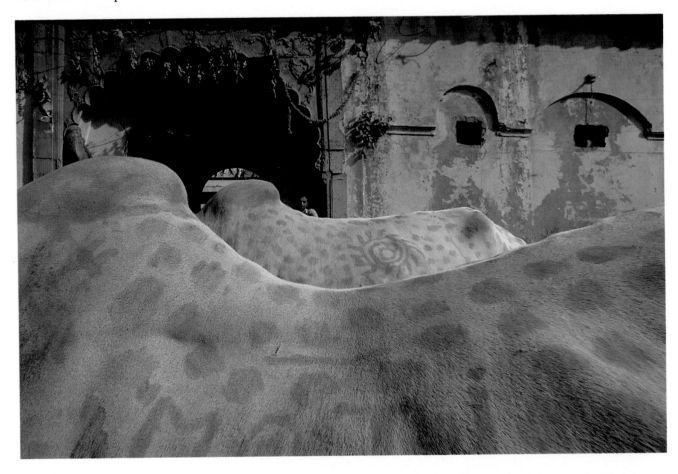

When Jane Walton, a graduate of my Travel Photography Workshop in Santa Fe, showed her photograph (right) at another well-known workshop, the instructor said, "This photograph doesn't carry enough information." Jane retorted, "My artist friends like it!" Do we wonder about the information conveyed in abstract paintings? Why should photographs always have to be vehicles for information?

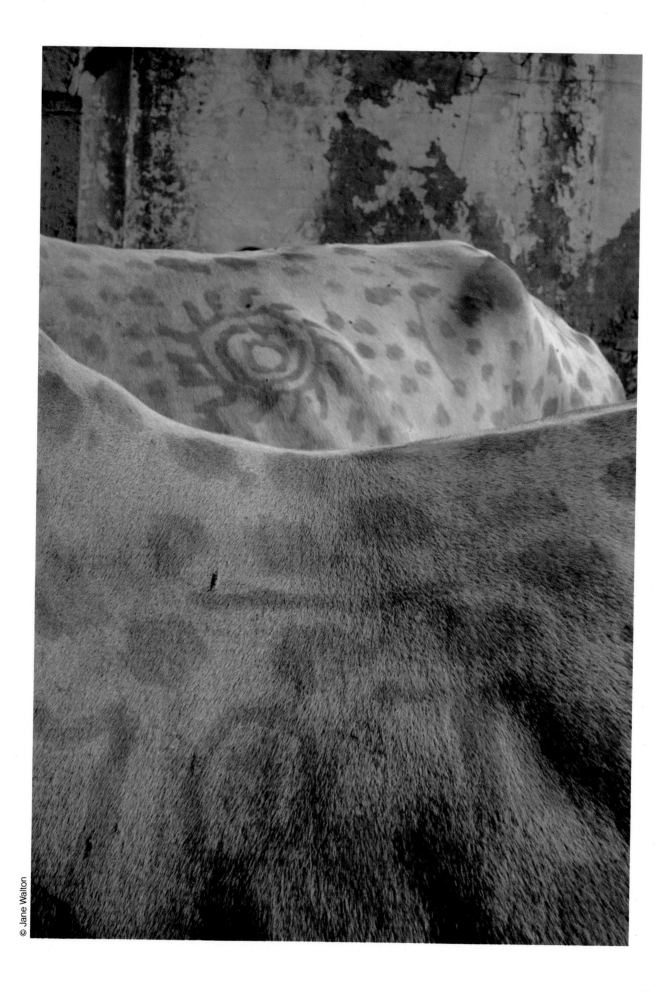

Emphasizing Patterns

The choice of format is critical when a pattern is the subject of the photograph. In Leningrad I was struck by the blue accenting of the architectural detailing on a wall. As I walked along the wall, I stopped to analyze the design on the bark of a birch tree. In the background I spotted the stripes and horizontal indents in the wall, echoing the markings on the tree. Despite the nominal subject matter, I thought this would be an effective photograph of the reverberation between natural and man-made elements.

Here the horizontal image conveys the dot and line relationship more effectively than the vertical, as the blue lines and tree give a stronger thrust through the horizontal format. These tensions are lost in the vertical. I recall my pleasure in the discovery of these dynamics; my mind and emotions fed on the revelation of such graphic orderliness.

All the vertical lines kill this photograph, especially in the vertical format that does not reinforce the design relationship between the tree and the background.

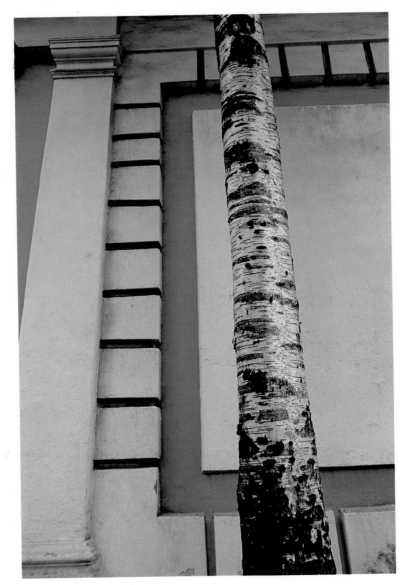

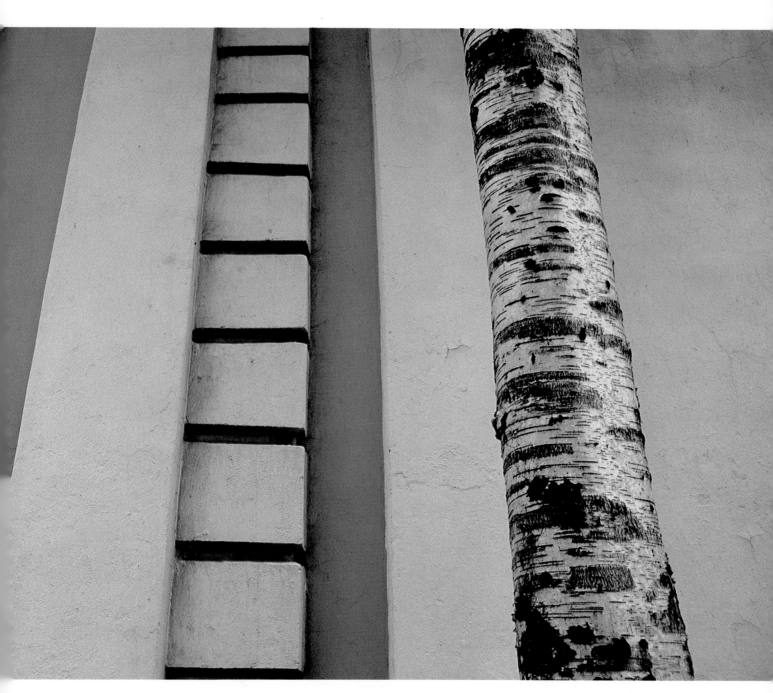

The horizontal format is more successful. Like musical notes, the horizontal lines on the trunk relate harmoniously and directly to the indentations on the wall. And the horizontal composition creates a tension lacking in the other photograph.

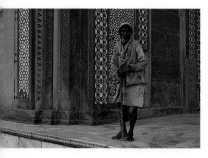

Conveying Information

The choice of format may be crucial to the conveying of information. In the birch tree photograph the horizontal format maximizes the energy between the dot and line elements within the frame; format considerations here have to do with formal aesthetic issues. My format choice in the picture of an Indian beggar is driven by other considerations, in this case the question of which format gives more journalistic information. In the vertical, the inclusion of the hands resting on the cane, and more of the clothing, tell more about the man than seeing just his feet. The curve in the cane counters the bent leg in a subtle, complimentary way. And the grillwork background gives a greater sense of place. Incidentally, I asked the man to stand against the grillwork, knowing that the relationship between his plaid clothing and the tracery pattern would be graphically effective.

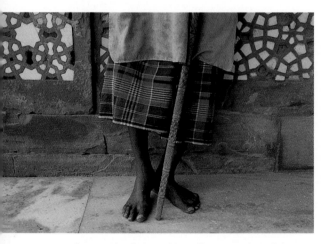

If Manet had seen this Indian man, he might have painted the beggar. I don't avoid subjects many photographers feel are too sensitive to focus on. And I didn't avoid playing up the man's gimpy leg and cane. In a vertical format, they are the symbols that tell the story of his condition.

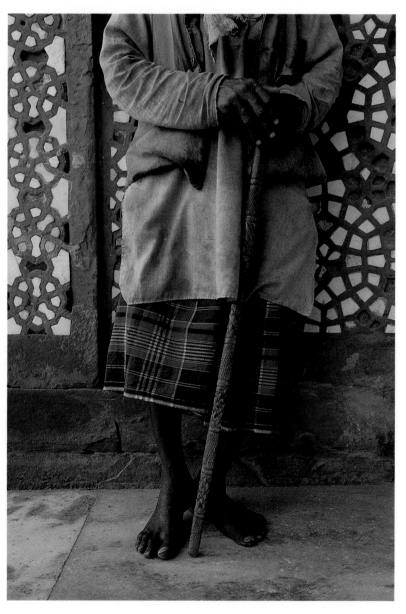

Visualizing Verticals

It must be obvious by now that I'm emphasizing vertical formats in this chapter. That is because vertical formats run contrary to the normal lateral human vision, and, for this reason, many photographers find it more difficult to visualize verticals. Another impediment is that it takes more effort to hold a camera, compose, and shoot vertically without using a tripod.

Because we do not naturally view the world vertically, photographs taken in this way are apt to be more arresting. As a young photographer, I shot many verticals, and art directors were grateful, commenting on how few good verticals they were given. Today, however, I find that I have to concentrate in order to make vertical shots. Horizontals seem to come easier with age. In these photographs of wool, the vertical format is clearly the stronger of the two.

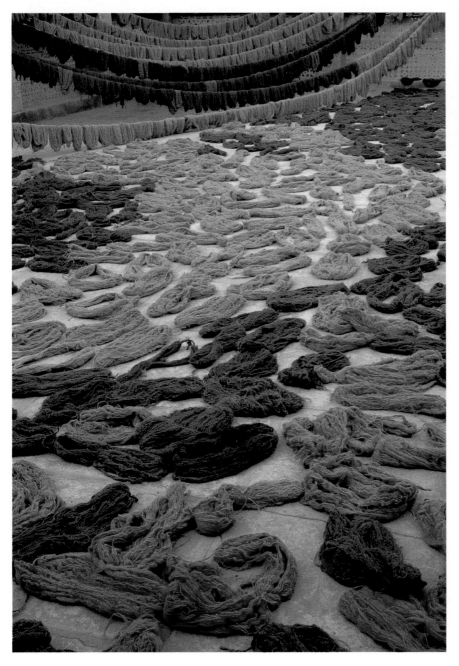

The vertical format controls the color in these photographs better than the horizontal does. The eye swings up through the rust-colored wool to the swags at the top of the vertical image. In the horizontal, the eye has no precise place to begin and end, which is visually unrestful and dissatisfying.

Point of View

Point of view is what determines our entire human experience. While it is not synonymous with style, they are concomitant. Point of view is the position you take; style is the manner in which you express that point of view. Working together, they effectively communicate your ideas and images.

Discovering a point of view, or angle, for each image I make is the single, most exciting thing about my life as a photographer. I feel the same way about choosing the best picnic spots from which to see the scenery. For me, there was only one best way to convey the power of the Zia symbols on a building in Santa Fe, New Mexico.

Because point of view is the product of our personal and creative DNA and lifelong environmental conditioning, it is not academically acquired. It must be uncovered, excavated through whatever higher process one takes to heart and mind.

In Santa Fe, New Mexico, the decorated corner of a paint shop invited me to take a strong skyward angle by moving in close and shooting up with a wide-angle lens. I dramatized the Zia motifs, Native-American sun symbols. The diagonal balance of the shadow areas adds power to the composition, embracing the color with coldness.

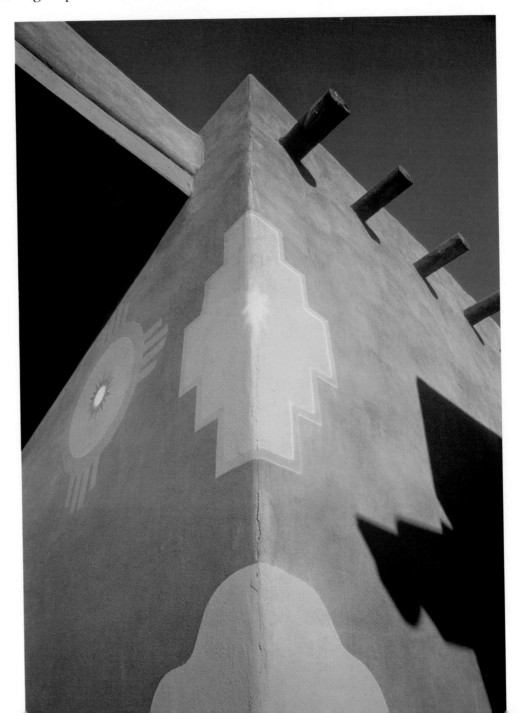

Angling Light

Since the sun is a natural provider of strong angles, the play of light and shadow on the material world is a constant subject for strong graphic images. Early one morning I walked along the changing bungalows at Forte di Marme, an Italian beach resort. The linear effects were wonderful, with the vertical floorboards obliquely intersected by shadows. The slatted siding and railings had great linear qualities, as did the classic beach umbrellas. The colors, too, were appealing; it was a natural graphic setting, and the three angles I explored resulted in very different photographs. The undistorted detail of the umbrella tops conveys the relationship of the colors in a minimal way. The vertical deals with the thrusts of line and light expressed through ultra-wide-angle distortion. In the less distorted horizontal, the railings come into play.

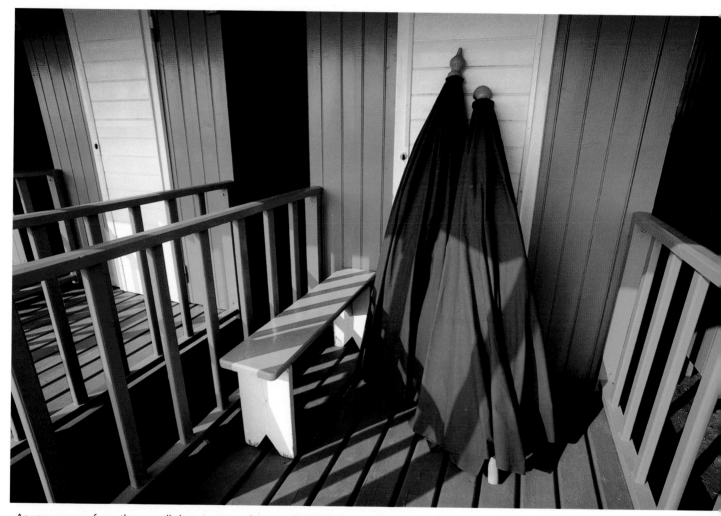

As you can see from the overall shot, I removed one umbrella and a pole before taking these photographs at *Forte di Marme*, an Italian beach resort. Many people have a tremendous reluctance to move objects for a better photograph. They feel they are committing an offense. If no one is around, I simply move things, take my picture, and put them back. If someone is there, I politely ask permission to rearrange the elements to suit my photographic needs.

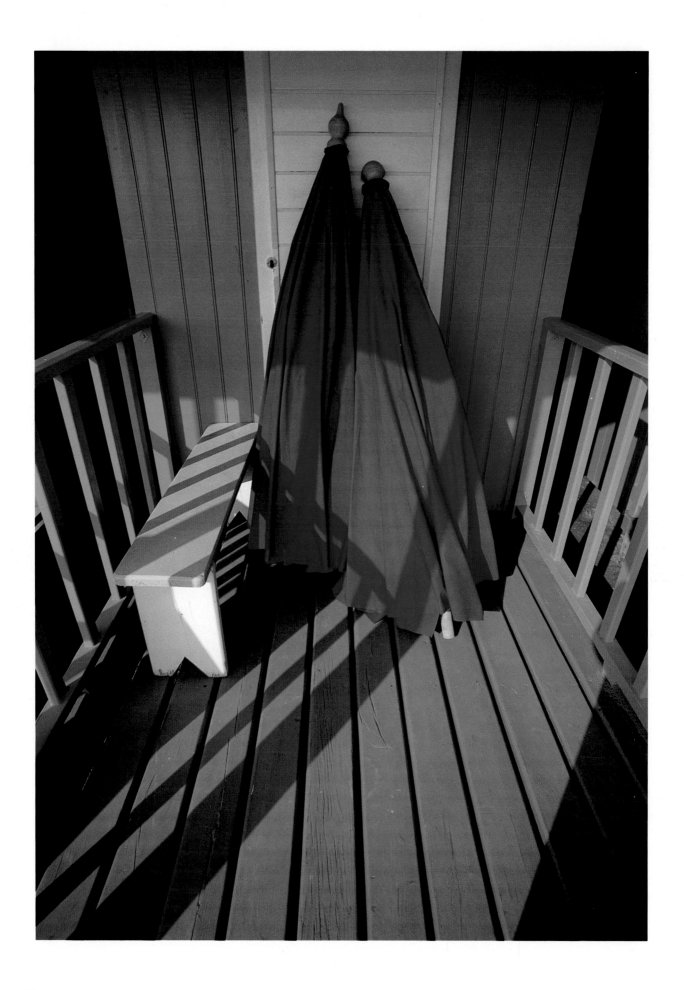

56

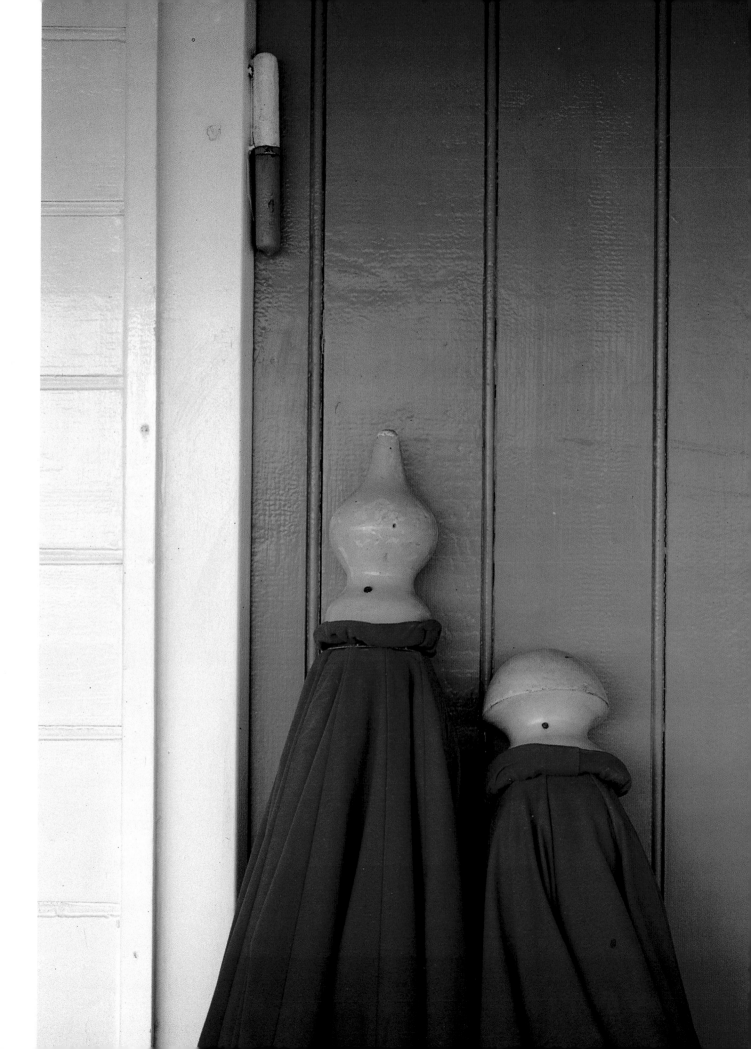

The Origins of Style

My photographic style has emerged from two imperatives: the practical and the personal. The practical has to do with the limitations of the material world, versus what I want to express. At Katmandu's Swayambunath Temple, unattractive outbuildings blocked the view of the gilded spire. When, to avoid them, I went up close to the spire, it became immediately evident that only a wide-angle lens, aimed upwards, would contain the image I wanted.

Because I needed to solve optical and environmental problems, I sought a practical gesture, not one for aesthetic affectation.

In Tunisia, a totally different situation provided a similar image, this time resulting in compositional dynamics. My style here resulted from a personal imperative, since only a wide-angle lens, aimed up, could convey what I felt about the relationship between the stripes, the blue, and the window. Here, style became an aesthetic gesture.

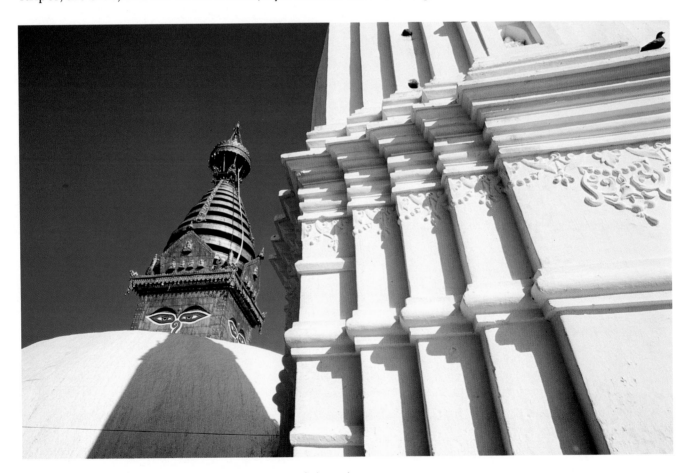

At Katmandu's Swayambunath Temple, I was concerned about the amount of white. While working out the angle through the viewfinder, I realized that the vertical shadows broke up the white volume satisfactorily and provided dramatic directional lines to the composition.

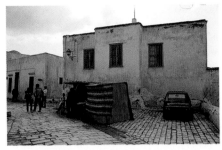

The strong diagonal lines support the blue volume in this Tunisian composition. Making half the photograph a plane of blue in the middle of the composition is an unusual graphic treatment in photography. A painter wouldn't question it.

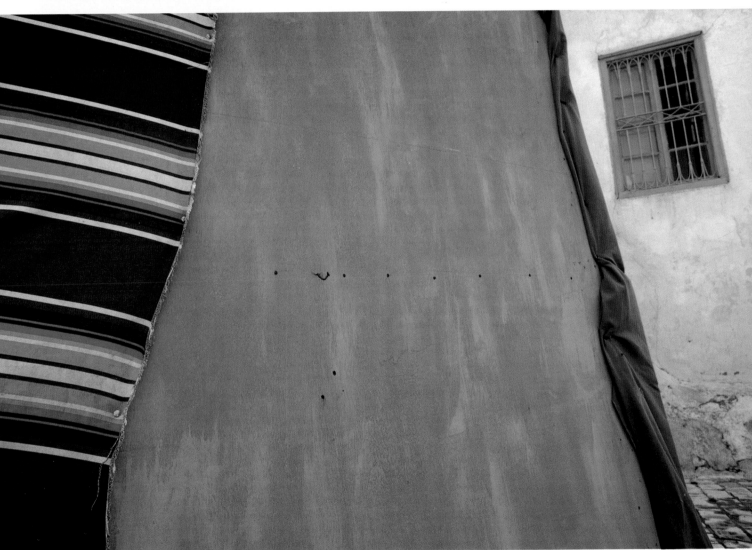

Dimensional Dynamics

As these photographs of rugs for sale in Jerusalem show, my work is highly dimensional, the result of wide-angle optical fluency. This is simply my style, and does not imply that I think it's more aesthetically virtuous than a more two-dimensional vision. Indeed, there are photographers whose soft imagery has a flat dimensionality. Pale-printed nude photography and diffused-light telephoto landscape photography fit into this category: work that is graphic in the truest sense of the word. I enjoy it very much, despite the fact that it's very different from my sharply focused, color-intensive wide-angle point of view. This is not to say that one should be locked into a particular style, but I do think our subconscious stylistic genes exert themselves more often than not. For me, a regular stylistic achievement of exaggerated dimensional order is fundamental.

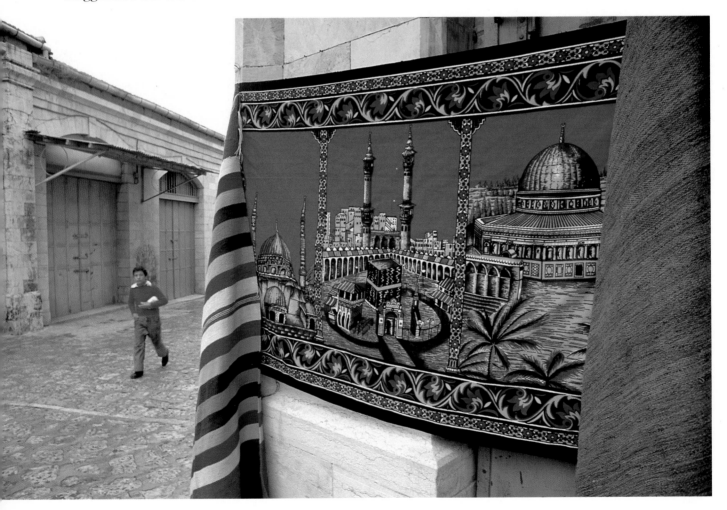

While all photographs are two-dimensional, the illusion of three dimensions is achieved here by opening up the image area to the street and the building beyond the corner. Using a wide-angle lens, I moved in quite close on the red rug and aligned the vertical axis with the building at the left. Wide-angle distortion exaggerated the volume of the rug, adding to the effect of depth.

Optical Explorations

In my teaching I've discovered that many amateur photographers become optically illiterate with their use of wide-angle lenses, feeling that the distortion inherent to wide-angle lenses is a distraction and a liability that must be controlled. I agree that distortion has to be controlled, but not in the same way or for the same reasons. If by control one means the minimizing of the visible effects of distortion, control might be desirable in architectural and interior design photography. In other fields of the medium, where more interpretive optical approaches can be taken, distortion is a powerful asset, not to be avoided. In travel photography, for example, there is no reason not to optically reinterpret the world. After all, the "traditional" shots were all taken decades ago. The only hope of establishing a personal style and graphic edge is to seek out nontraditional travel themes, and take fresh optical angles on traditional subject matter. For example, at Egypt's Temple of Philae, I used an ultra-wide-angle lens, up very close, on a carved piece of fallen rock. The result: controlled use of distortion.

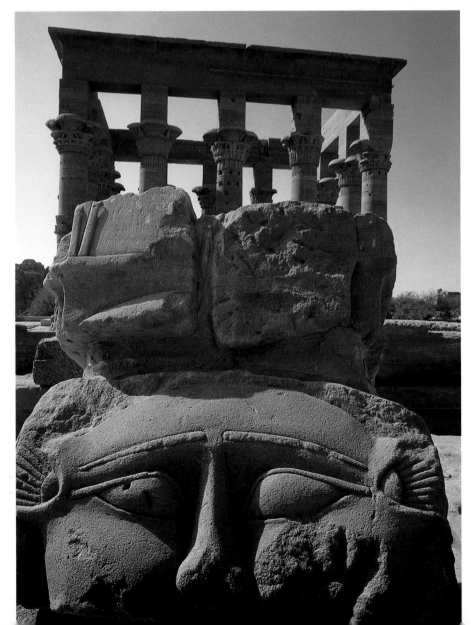

Acute awareness of relationships go into compositions like this one, of Egypt's Temple of Philae. I consciously controlled the amount of black shadow at the bottom and allowed the capitals of the columns enough breathing room at the top. The foreground element is highly distorted, to create a surreal optical effect that enhances a traditional travel subject.

61

Uninhibited Angles

I frequently have to explain my habit of fragmenting the human body. It's certainly not because I don't like people! It comes from wanting to investigate a detail, or focus on a cultural idiosyncrasy. The rings and bracelets on this Indian woman can only be highlighted with an angle down on her feet. The reason I didn't move in closer is that I liked how the man's white clothing led into the chalky coloration on the ground. In Jamaica I was photographing the inside of a boat when a man came over to watch. I visualized how graphically effective it would be if he were to stand in back of the boat, with his towel repeating the red splotch in the bow. I didn't realize just how graphic, until he stood there. Are people inhibited by their body parts being photographed? No! Only photographers are. These people are used to their bathing suits and bare feet.

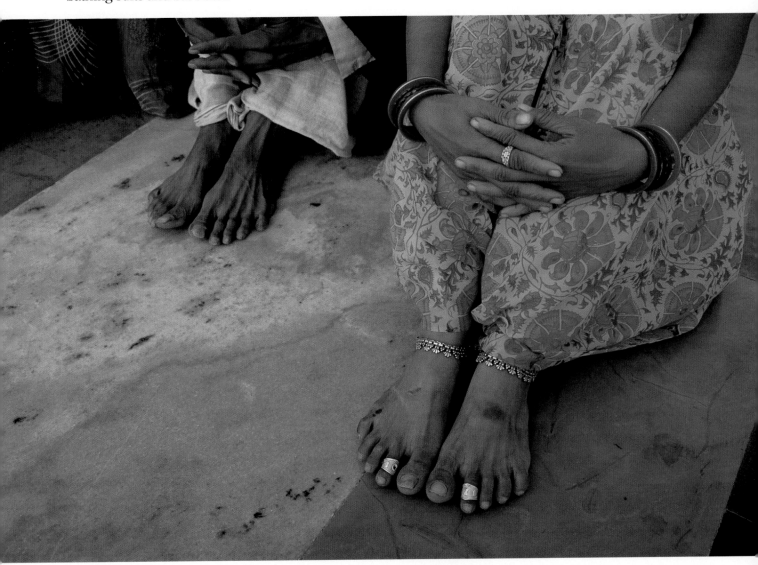

The mottled floor appealed to me at this Indian temple. While some people might consider the floor to be grubby, I thought it was beautiful and evocative of the culture. There are no spanking new floors in India.

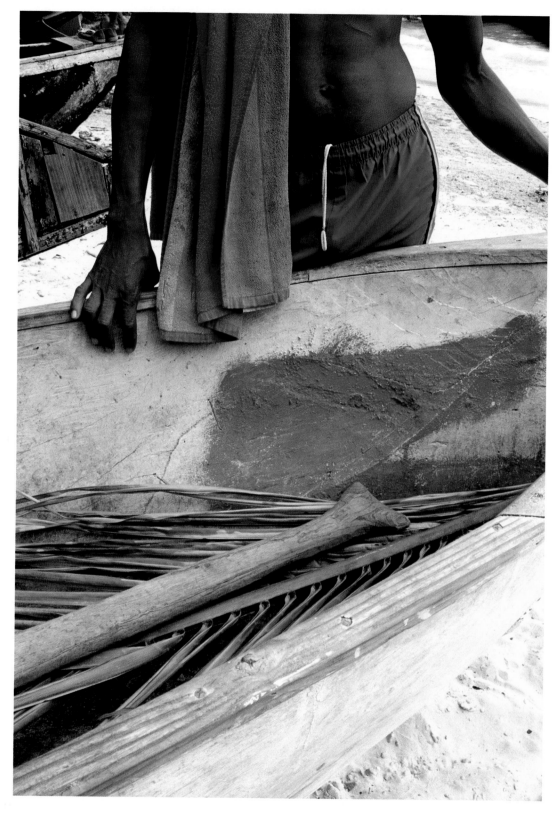

Spotting me as a professional photographer, this Jamaican "Rasta" man asked for a tip. I demurred and started to walk away. "Come back, maahn," he said. "Take your picture. Ya gotta do what ya gotta do!"

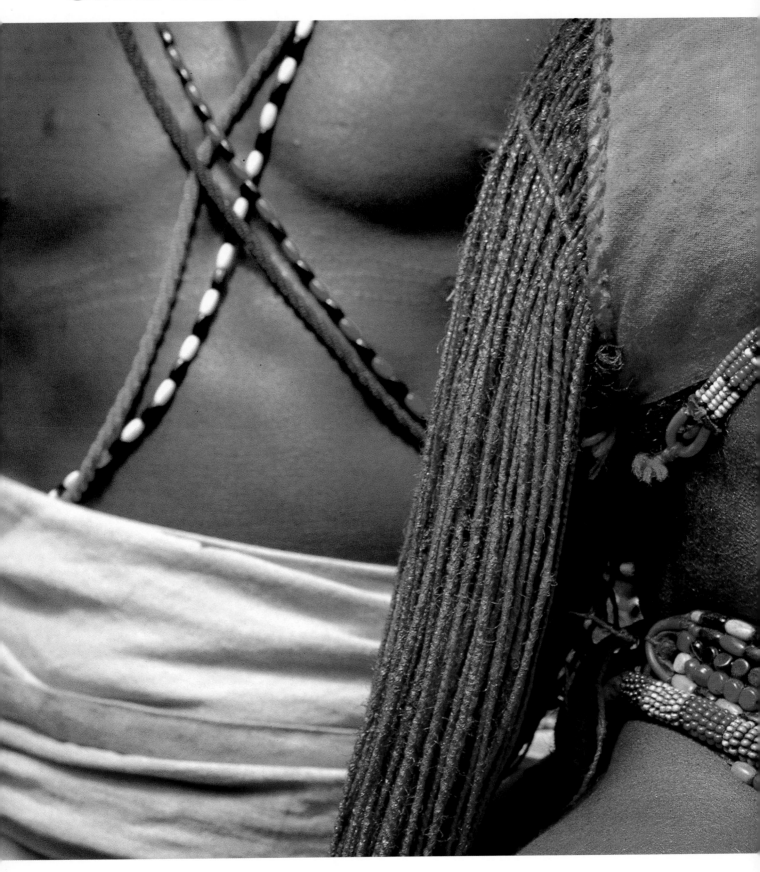

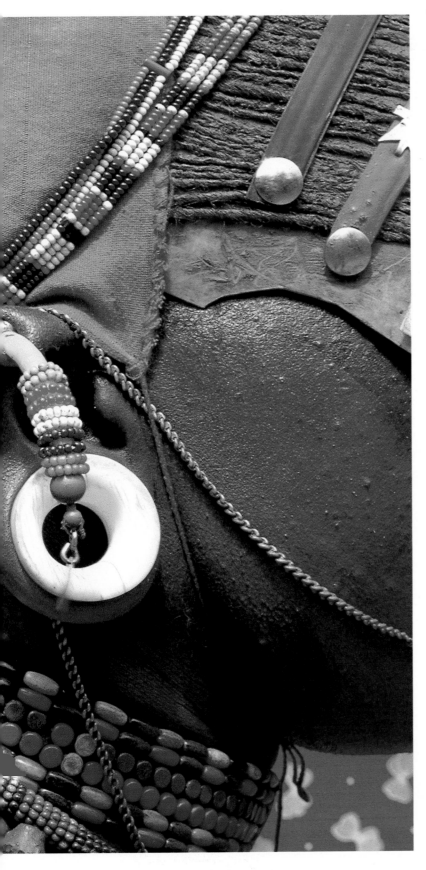

We forget with our all-too commercial use of the word "graphic" that it means "vividly described, lifelike". We are attracted to a subject, even a stone, by the qualities of life it displays. In turn, we give that subject new life by translating it through our vision.

This chapter is filled with graphic attractions not often placed side by side. We are not surprised to find light and texture together, nor balance and mood. But "mystery" and "challenge"? They are subtexts, the invisible binding forces that, recognized and utilized, create the graphic seamlessness that provokes and touches, urging the camera to become much more than a mere recording device.

Only a wholeness of vision, fostered by an intuitive awareness, the trust in one's own intuitive resources, leads to this graphic integrity. And it is then that viewers, sensing a completeness that mirrors their own, say, "Ah, yes. That's it."

You will notice in my descriptions of these graphic attractions that it is always a partnership: what I bring to a subject, together with what I find in the subject— for example, England, Morocco, Brazil— that gives me the "click" that is much more than the sound of my shutter.

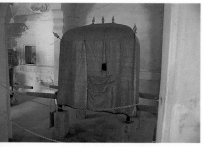

Mystery

"How do you see?" is the question I am most frequently asked. In this chapter I'll illustrate how I see, showing situations I've been drawn to and explaining my initial attraction and how I distilled the subject into a graphic image.

A maharaja's palanquins in an Indian museum, for example, were of historic and social interest, but, as a whole, of no photographic interest to me. As I wandered through the room, I noticed ripped fabric and a black peephole. Looking through it, I felt the mystery of centuries, the murders and romances. The dark hole and the torn, sensuous swags of yellow and orange silk made a natural graphic image. I'm not concerned that the subject is obscured. This is a "feeling" photograph conveying India's overriding—if not overwhelming—atmosphere: mystery. As photographer Diane Arbus said, "A photograph is a secret about a secret. The more it tells you, the less you know."

The literal mind responds to this situation with the question, "Why waste film on ripped cloth?" The creative mind doesn't see it literally as ripped cloth, however. It sees it as a cluster of sensuous graphic shapes and a mysterious hole that lures the eye into deepest, darkest India.

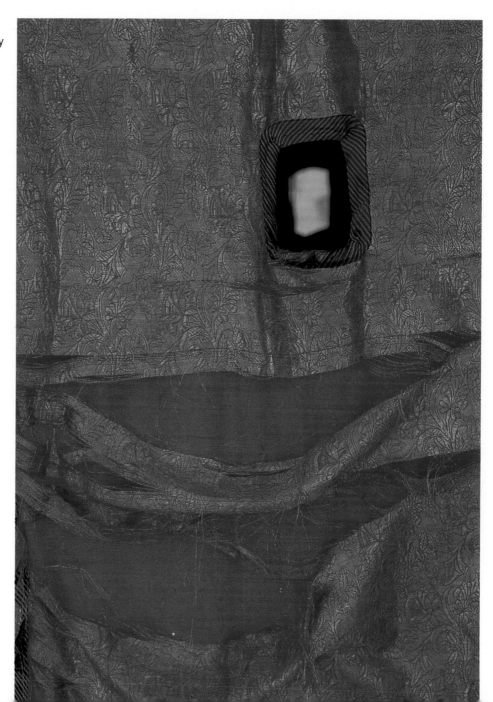

Texture

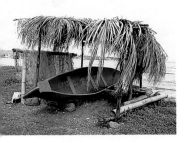

Memories of my country childhood are textural ones. In the fall, I often let myself fall into enormous piles of crisp leaves. In the winter, I took long, lonely walks through gray, skeletal forests. In spring, I lay on furry, fresh grass. In summer, I walked barefoot through soggy wheat fields after thundershowers. That's why, as an adult, I'm magnetically drawn to textures, especially natural ones.

The three situations from Jamaica, Morocco, and Indonesia need little explanation, except to say that the tight, graphic compositions magnify the textural quality of the subjects. I feel that photographs are really self-portraits, symbols from the external world that correspond to our inner truths, photographic metaphors of our subjective reality. That we project our own reality is an idea currently pressing on Western thought in the minds of many, and it is an idea reflected in the art of the eye and the mirror: photography.

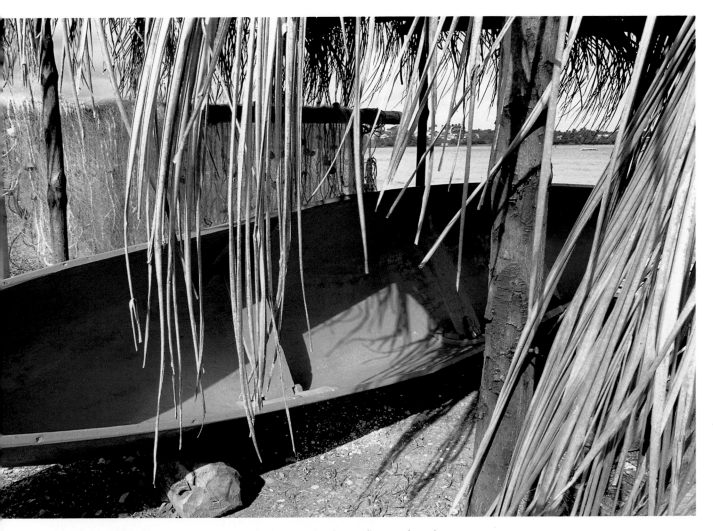

When the sun popped out on a gray day, I shot quickly. The sunlit grass hanging on the shelter, and the highlight and shadow areas on the boat, turned a potentially dull picture into a graphic Jamaican image. Consider the same shot in flat light. It would be a picture of a boat on the beach . . . period.

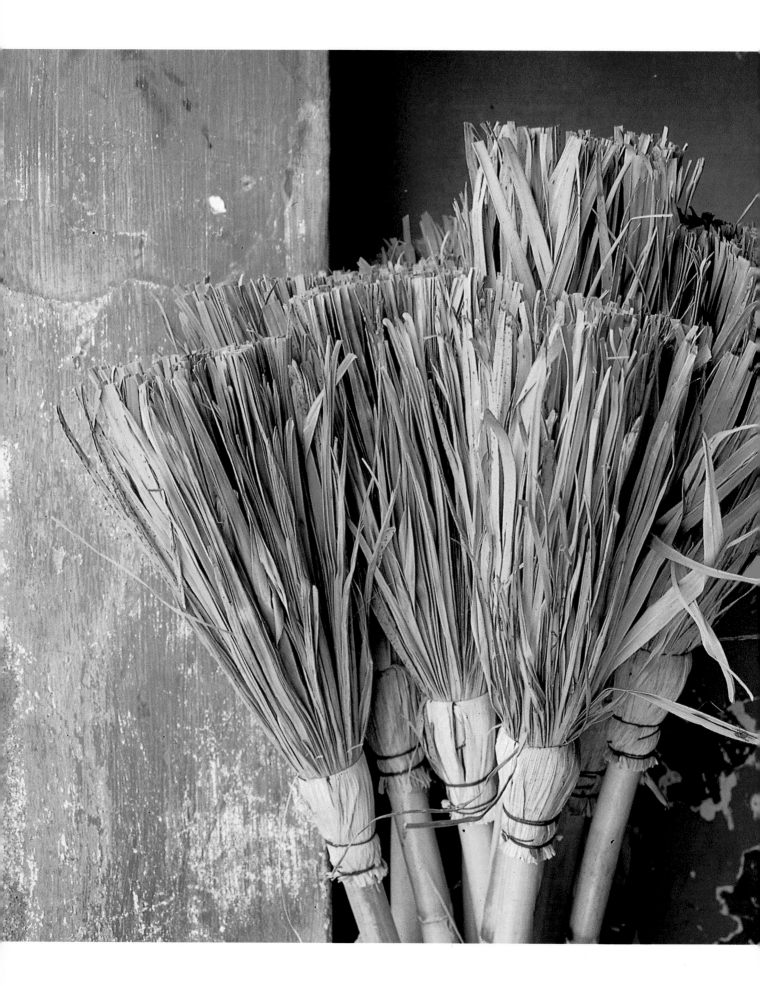

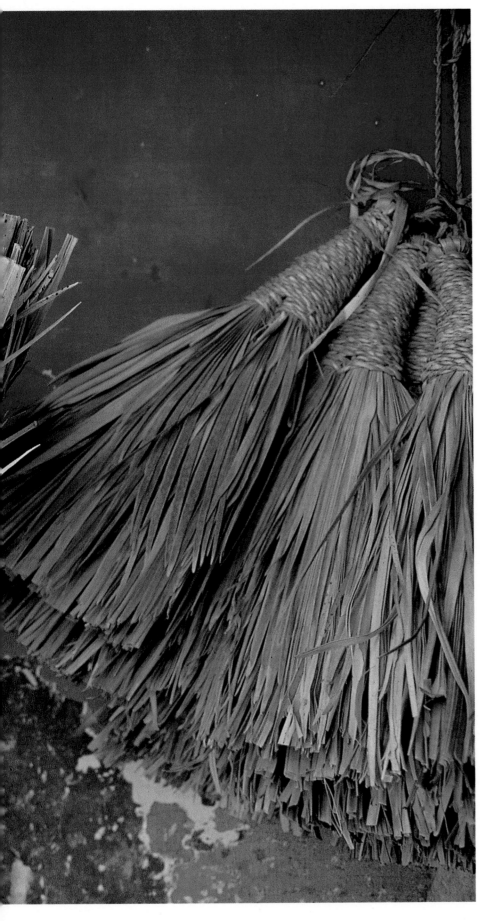

I am drawn to brushes and brooms all over the world. Often they are appealing, locally crafted items. Here the contrast between the sunlit brooms and those in the shade, juxtaposed against the two values of blue, makes a textural Moroccan image.

69

At first I was photographing this Indonesian child in a composition I knew wasn't very exciting. It was a standard ethnographic travel shot. Then I zoomed into the right on a far more successful image. The tied-up rice against the painted background creates an appealing graphic relationship of pyramids and upward thrusts.

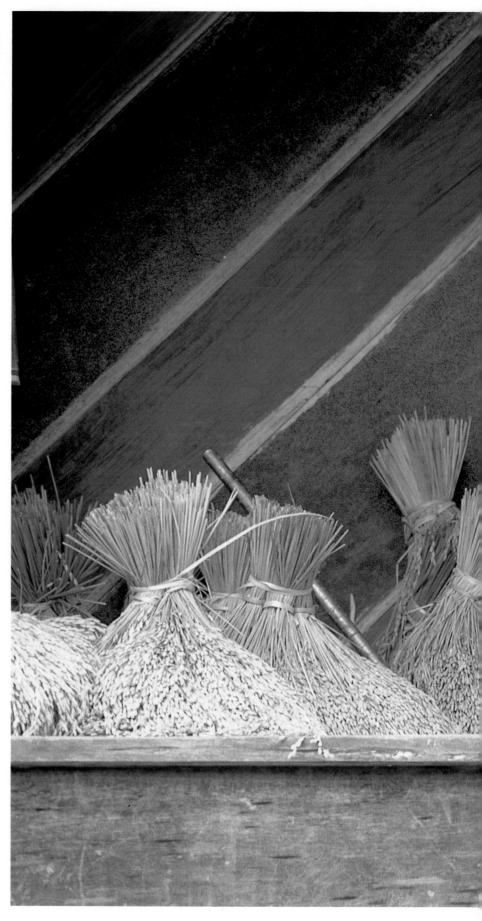

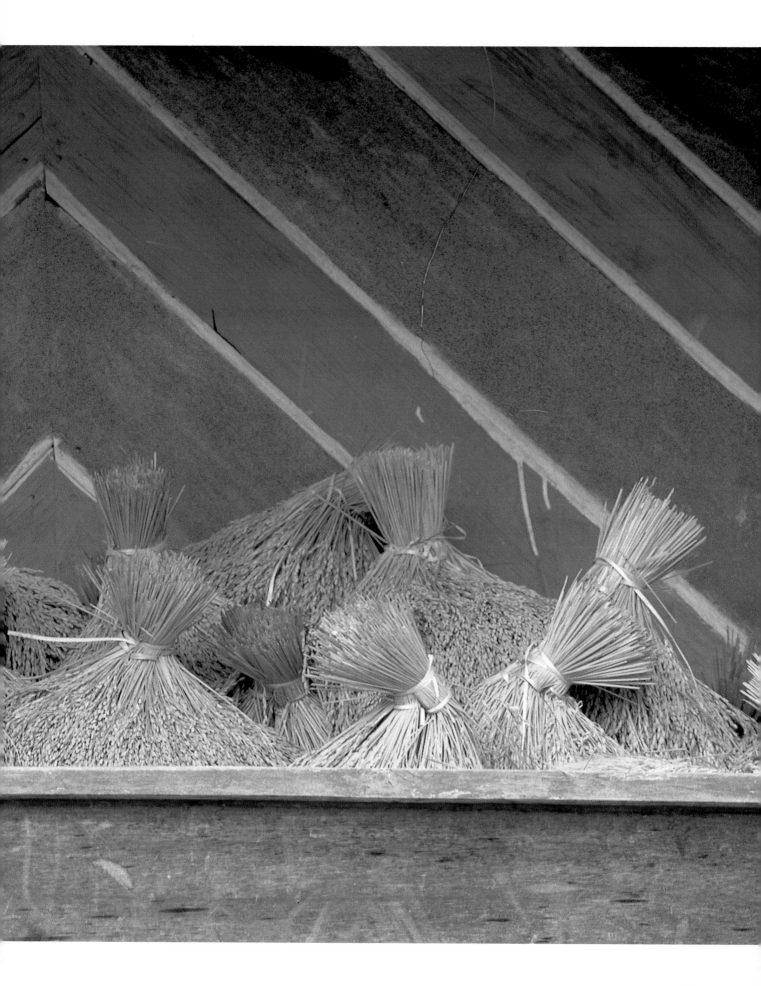

Rhythm

Riding along a Portuguese coast road, I found myself following the rhythm of the wave motif in the cobblestoned sidewalk. When the bus stopped, I noticed a boat on the beach. The symbolic wave motif, in one form or another, could be found all over the country, in weavings and pottery. Cued by that knowledge, I got off the bus in search of a photograph of the motif and the boat beyond.

A wide-angle lens enabled me to move in and magnify the motion of the wave. I waited until there was a line of white froth in the water, to add further interest to the horizon on this gray day. The flat light and monochromatic colors accentuated the movement of the wave design, the most dominant element in the photograph. Knowledge of what something is can cue us into photographic action. But if I hadn't known about the symbolic motif, it would still have had graphic attraction for me.

"Photographic inertia" is my term for any argument that prevents us from pursuing the pictures that attract us. Arguments such as: I'm too tired, I would have to stop the car, I have the wrong film in the camera, or the light isn't right. Here I almost let the gray day keep me in the bus—a good excuse for not acting on this picture possibility.

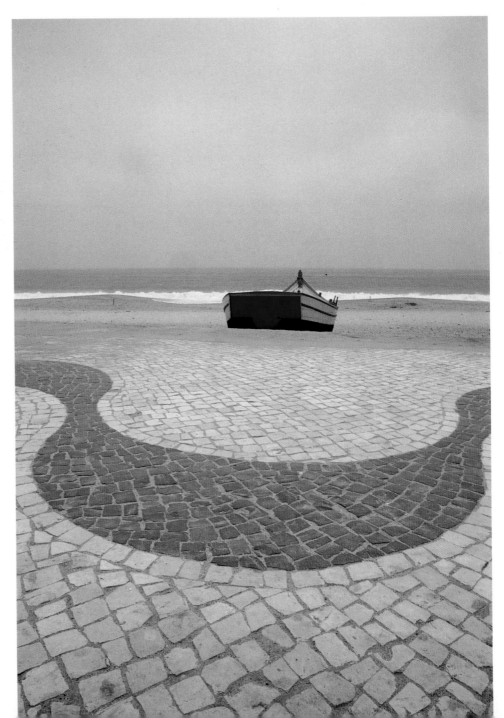

Tradition

Many cultures' traditions are on the endangered images list, and chief among them is the time-honored home delivery of milk in England. When I saw this bottle in Woodstock, I popped out of the car to record the picturesque custom. Graphically, I was attracted by the yellow and white door but, to tell the truth, the bottle was set a couple of stoops down against a dreary door—until I moved it.

As luck would have it, the milk's owner returned from walking the dog as I was absorbed in the formal considerations of the white bottle and white trim. After a charming exchange and my promise to return the milk, I continued pushing the bottle back and forth within the vertical format. Using a tripod, I decided the bottle looked best under the dominant white line, and I took care not to line up the bottle precisely with the edge of the white trim.

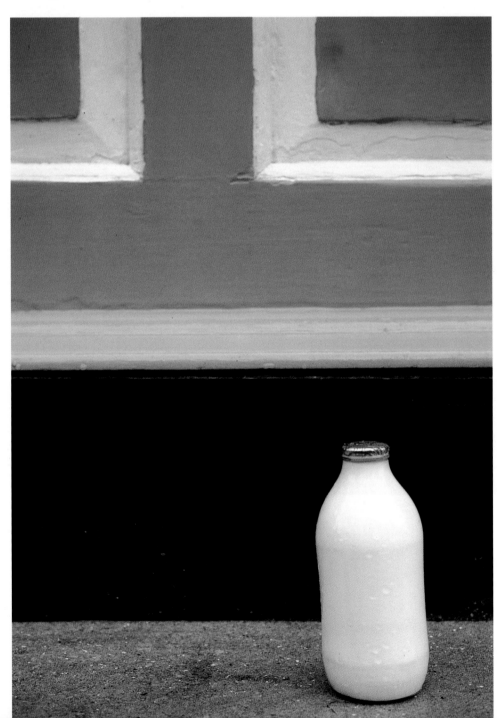

From the graphic standpoint, it's the black base of the door that makes this photograph. The black accentuates the milk bottle. I strove not to line the bottle up with the white line; I felt it would be too static in an otherwise very structured composition.

Balance

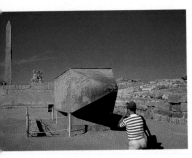

Balance, more than any other quality, is what I strive for in my photography, before I consider color, texture, personality, or beauty. This pursuit gives me the opportunity to establish an exquisitely balanced tension that I find thrilling. Other qualities may catch my initial attention, but if I cannot express them in a balanced image, I'll walk away from the scene.

There may be no higher manifestation of man-made balance than in Egypt, with all those stones piled high in pyramidal shapes, and obelisks still standing after thousands of years—except this one at Luxor, which did not endure. I watched people photographing the remains as it lay on the ground. "So what?" I thought. But as I moved closer to the obelisk to investigate it through the viewfinder, I was overwhelmed by a powerful image of asymmetrical balance.

I'm not saying that symmetrical balances must always be broken; frequently, all elements in my compositions are balanced, vertically and horizontally. I find both symmetrical and asymmetrical balance equally attractive.

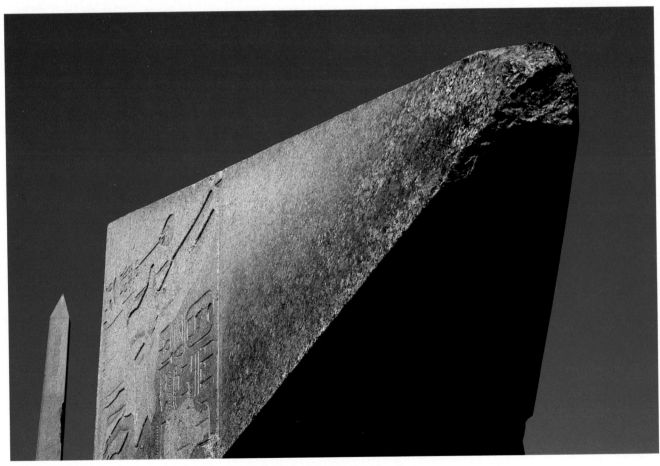

The black shadow on the underside of the tip of the fallen obelisk supports this composition . The distant obelisk explains the dominant abstract foreground. Even in its diminutiveness, the small distant obelisk manages to balance the massive point.

Color

Color always attracts me. In photographic situations, I'm drawn to colors and color combinations I could never live with or wear.

In Portugal, the stacked green and blue chairs seemed to be set up just for a photograph. The chairs gained an abstract quality when I moved in close and filled the whole frame with them. They became a compelling snarl of color, momentarily losing their identity as chairs.

In Jamaica, a red and orange combination is greatly enhanced by the contrasting white pickets of a fence, with the dribble of blue a whimsical accent, a primitive afterthought.

In Morocco, it was the relationship of the other colors to the pale blue in the shape of the keyhole that caught my eye. At issue was the organizing of arbitrary areas of color. The little strip of white alleviates the composition—a note out of nowhere—and effectively "holds" the lower left corner.

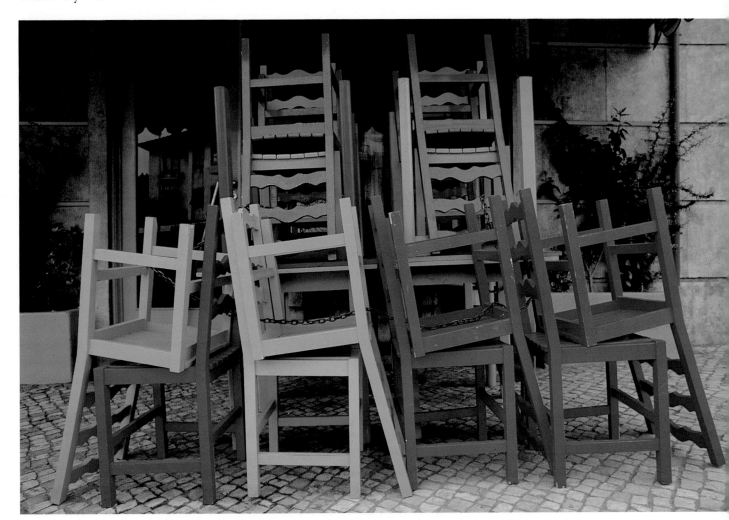

As I walked past a Mister Pizza parlor on a dull day, these bilious green chairs popped out at me from an otherwise drab environment. On overcast days colors can look more intense because they aren't washed out by strong sunlight.

81

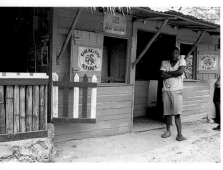

Stopping at a Jamaican
roadside restaurant, I saw this
red Dragon Stout sign. With
its island color scheme, the
company logo struck me as
amusing. I used a tripod and
a slow shutter speed in the
low light. Locals, wondering
what I saw in this situation,
queued up to look through
the viewfinder.

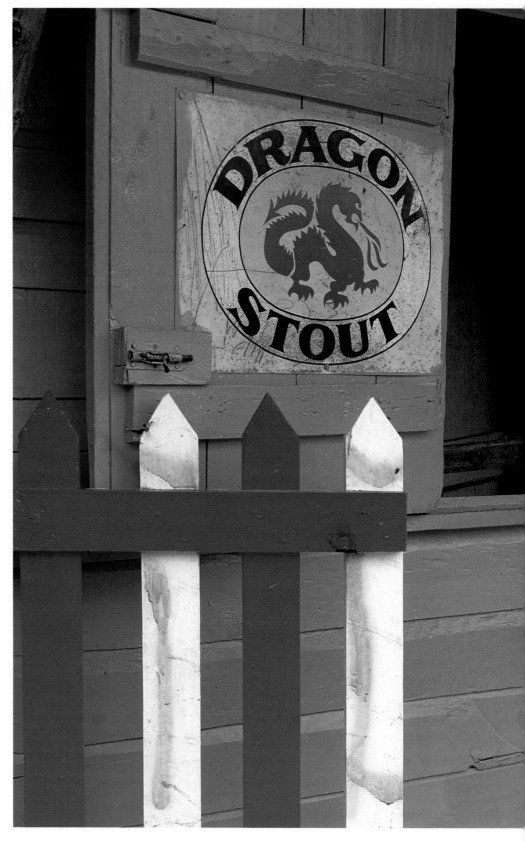

Doors and windows may be the ultimate travel photography cliché. It's important, however, not to dismiss overworked subjects. Even though I had overdosed on doors recently, I tried to stay visually alert to them in Morocco. This enabled me to connect with this abstract painting that happened to be on a door.

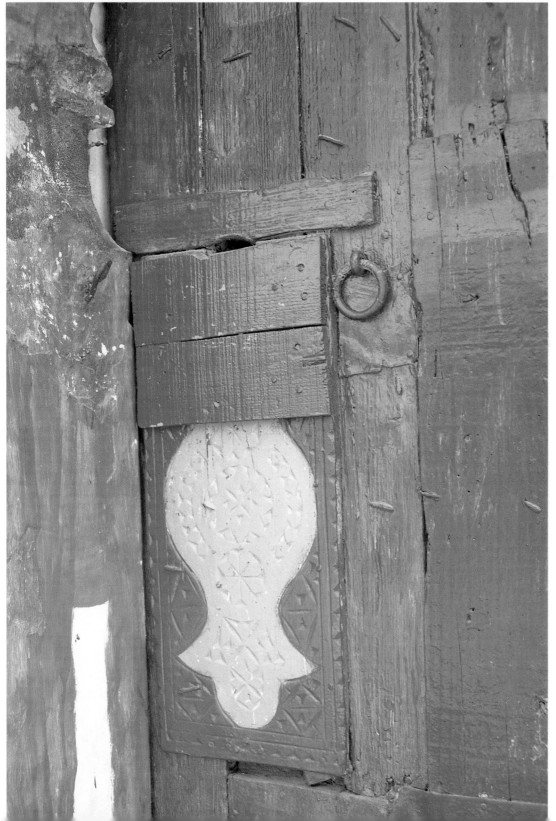

Challenge

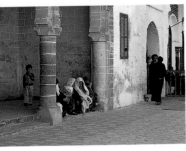

Photographing people can be a challenge anywhere in the world, but nowhere is it more difficult than photographing women in Moslem countries. In Morocco, women wearing traditional haiks sat in a row to chat and people-watch, as they do today. From a distance, I waved at them and raised the camera to my eye. As you can see, I got a definite refusal from all but one of the women.

This conspicuous public rejection could have blocked my awareness of the fact that one woman was looking right at me. She was not gesticulating or looking away. Accepting the challenge, I went right up to her, and she didn't even flinch as I raised the camera again to my eye. By this time the other women didn't exist for me, but when I stood up, they were all laughing over the experience. You must develop an ability to "read" people, and not immediately scurry off in embarrassment when faced with public rejection.

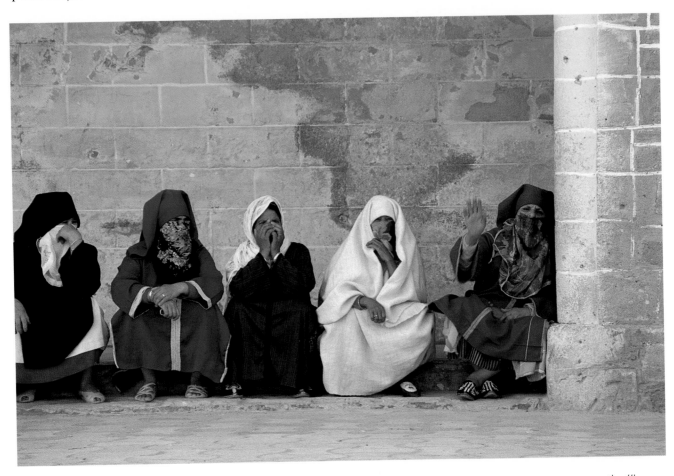

Waving me off and averting their eyes, these Moroccan women gave me the "leave us alone" sign. I had to overcome a good deal of inhibition to move in on the woman in white with a 55mm macro lens from about four feet away.

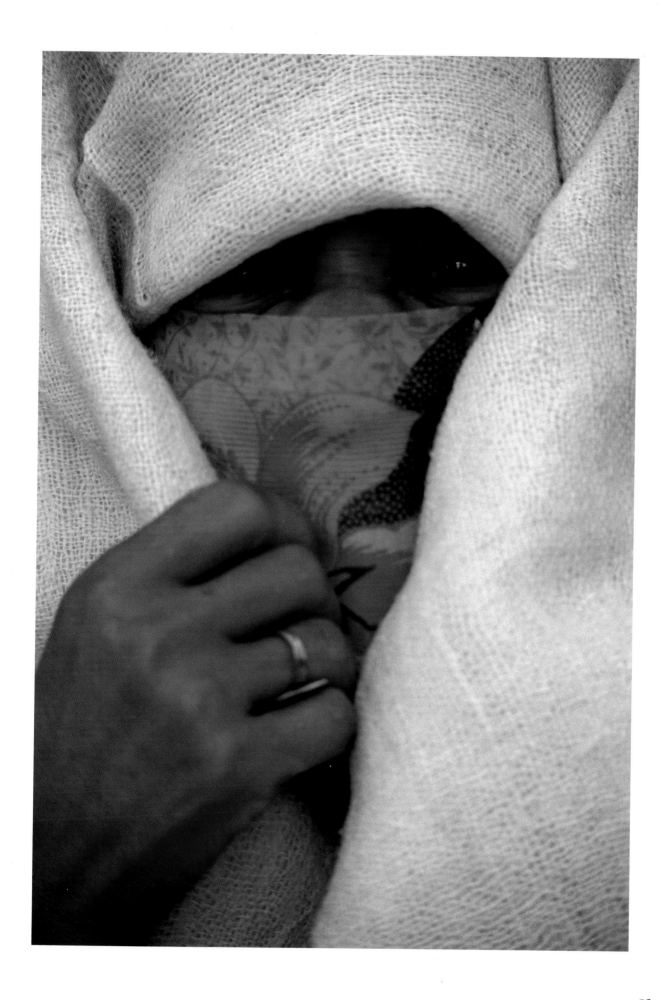

Light

The effect of light—a primal attraction—on the material world is what draws us to colors, patterns, shadows, and highlights. In these photographs light is the creator of abstract negative space: the interstice within an image mediating the more active areas. Here, the negative space of the shadow areas dramatically abstracts the images. To me, light is the primary subject of these images, which is easy to observe. Reading a great deal on the theory of light is unnecessary. Knowing why light appears harsh or contrasty does not enhance our initial response to it.

Film manufacturers are busy opening up the shadow details for photographers. While I frequently want shadow detail, there are times when a rich, opaque black is called for. I underexposed to achieve this effect.

In this case, shadow detail was important. Seeing the detail in the foreground shadow and the wall adds interest to this chiaroscuro composition. Professionals routinely bracket exposures to have some choice in shadow and in highlight detail. To do this, take the metered exposure, and then shoot one stop over and one stop under that exposure. You can also refine the bracket by shooting half-stops over and under.

Mood

Several years ago, when my husband insisted I photograph the red bag on the left, I was reluctant. "No one will know what it is," I thought, as I stared at the thing in the Palace Museum in Jaipur, India. Since then, it has become one of my most favorite photographs, and has been published many times. Back then, it was the only pigeon-proof bag over a chandelier in the arcade. Recently, on one of my photo tours to India, a few of us spent the afternoon photographing all the bags.

What I love about this place and the moody images I've gathered here is that many elements come together for successful graphics. Gorgeous color, for openers, a patina produced by decades of heat and dust and a sense of abstract, oriental mystery. Graphic structure is provided by the graceful architectural environment. The graphic potential of this place is inexhaustible. I'll return.

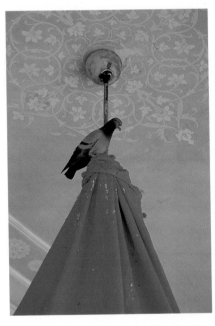

What are they? Pigeon-proof bags over chandeliers in Jaipur's Palace Museum in India. There was a spellbinding atmosphere in this place. I was alone, except for the pigeons cruising in to perch on the bags. I've returned to Jaipur several times and always find new forms in this situation.

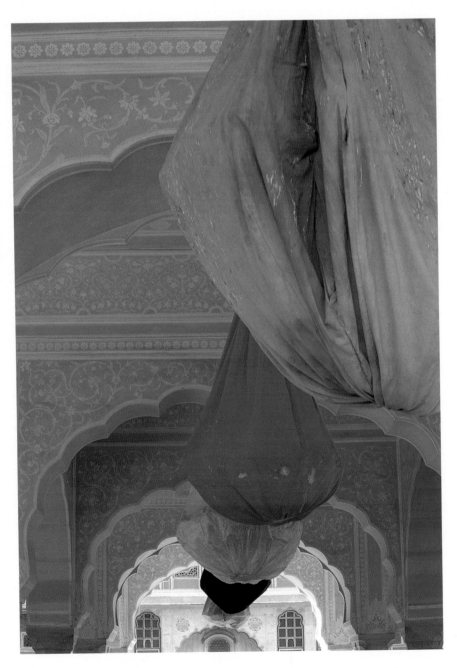

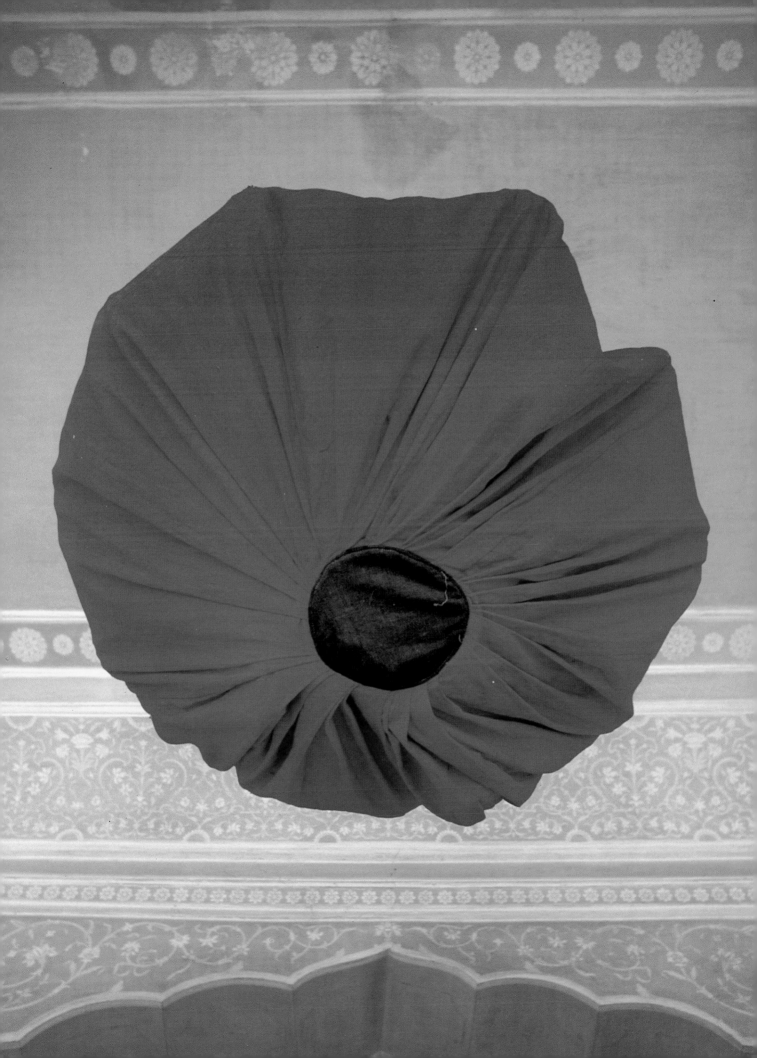

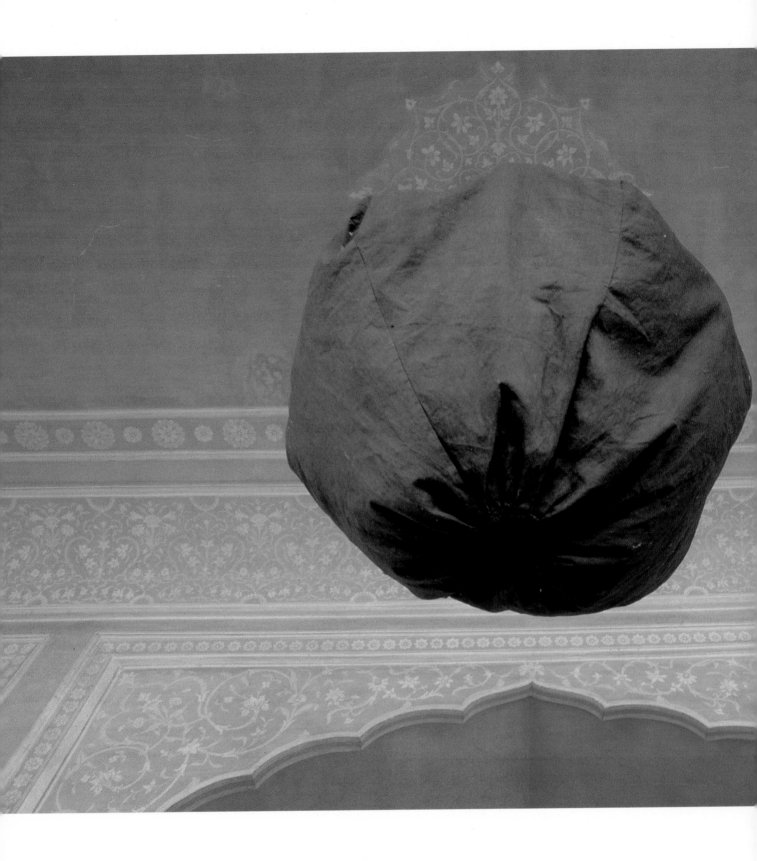

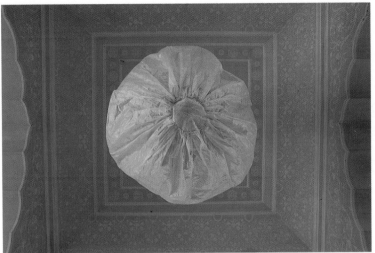

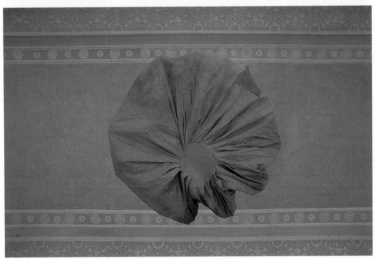

After aiming my camera up on a tripod for hours when I made these photographs, my neck asked why I was so drawn to these bags. The pure forms and faded colors appeal to me, as well as the challenge of capturing atmosphere on film. Whenever I'm photographing in India, I am amazed by this nation's unfailing ability to supply photographic possibilities and graphic mysteries found nowhere else in the world.

Beauty

Nature photography is probably as popular with amateurs as travel photography is. A flower photographer can have a field day at Giverny, the site of Monet's house outside Paris. The gardens are alive with brightly colored blossoms. While I'm not much of a nature shooter, I couldn't resist the attractive contrast of the red and yellow tulips against the purple flowers. At first, I was troubled by the sticks and struggled to angle them out of the compositions. Finding this difficult, I gave in, only to discover that they were an asset. The vertical lines, accentuated by using a wide-angle lens aimed down from a close distance, give structure to the images.

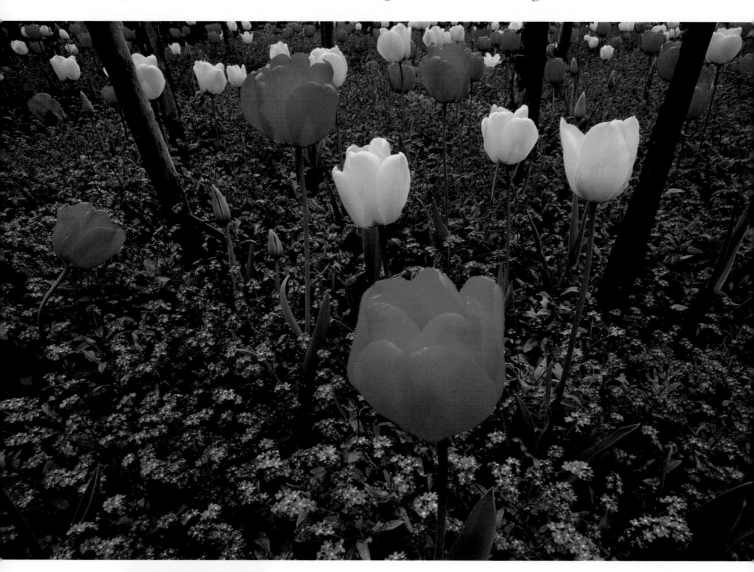

Mentally remove the sticks from these photographs and the result is simply pictures of flowers. The graphic sense is lost. In the closeup, the red flower and blades of grass against the purple caught my eye. I think it's the only shot that stands up without the sticks.

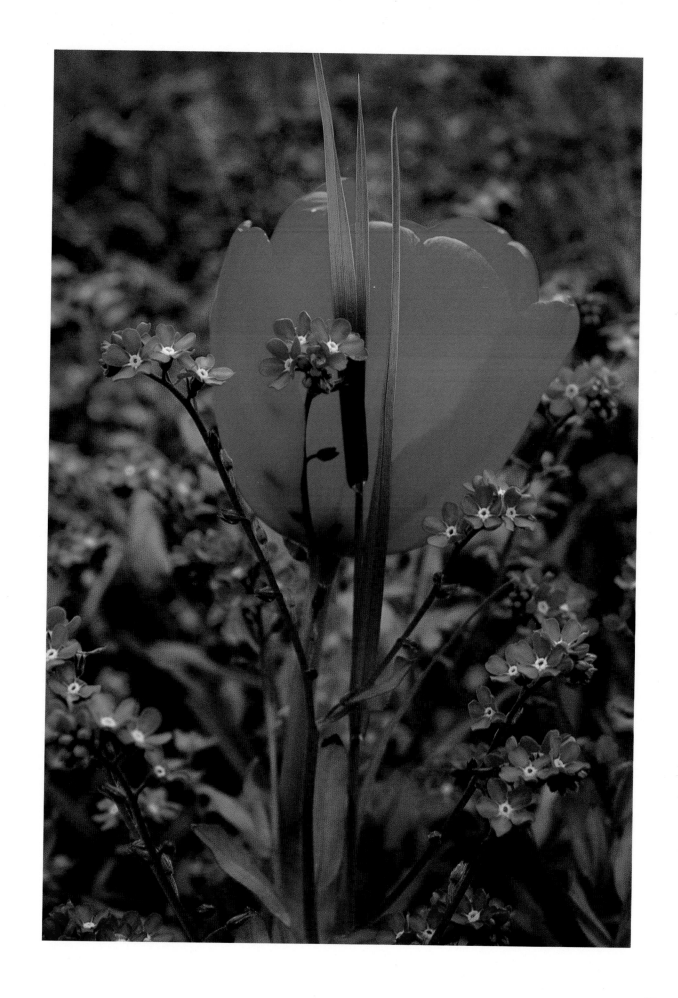

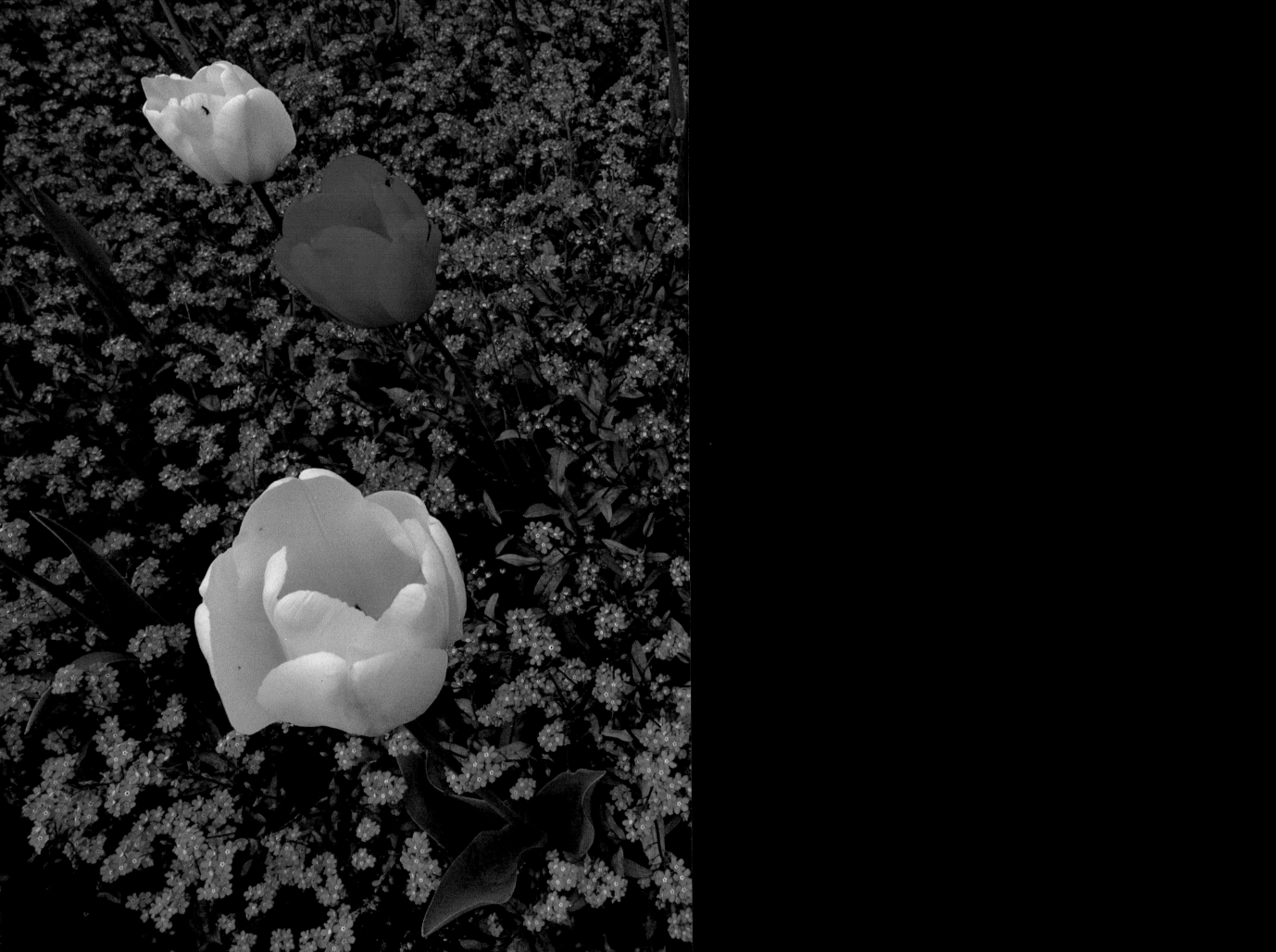

R eality resists abstraction. It wants to be taken seriously and insists on being recorded literally. If by abstract we mean nonrepresentational, then there is no such thing as truly abstract photography, for the most abstruse graphic detail is always extracted from material reality.

Photographers who want to approach abstract expression in their work must look beyond the camera's actual subject and develop a clear focus on what qualities they intend their images to convey—for example, physical sensations, emotions, or ideas. An "intellectual squint" is required to blur the literal subject and, thereby, reduce it to its fundamental elements: form, volume, color, and texture. Then a sense of graphic order that serves the picture's ultimate message can be imposed on the composition. If the literal subject still dominates the photograph, it may be a good idea to start over or to use a different subject matter to evoke the same response.

It is not only academic to say that lines are imaginary, it's also true. A line is only a figment of the imagination, something discussed in art school in relation to the three primary shapes: the triangle, the circle, and the square. Beyond artistic theories lies expression, and that is where the phrase "abstract photography" acquires its meaning and relevance as an artistic medium.

Expressing Feeling

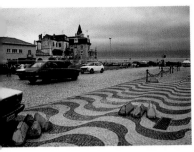

Dealing in line and shape, the visual artist uses raw materials to express feelings. I once read that "What artists do is to give form to feelings." The idea left a lasting impression on me and has guided my work ever since. If photographs do not convey feelings first, even before ideas, they fail. It is, after all, the mood of an image that first attracts people's attention, and the more graphically direct the composition, the more lucid the mood.

The two images here, while certainly not the most moving in the book, illustrate my point. Both depend heavily on line and shape. The first, the undulating cobblestoned sidewalk with contrapuntal street blocks, exudes a feeling of rhythmic motion, with the yellow adding a warm note. The street blocks, while not objects of intrinsic beauty, act as abstract volumes against the curvilinear cobblestones. The overall feeling of the composition transcends the photograph's subject matter.

In the second photograph, the static organization, combined with the cool coloration, evokes a harder, more formal feeling. While no less graphically successful than the first, the cold blue composition does not draw in the viewer or invite as much interaction.

The cool color relationship attracted me to this street scene in Obidos, Portugal. The symmetrical composition strengthens the impact of the color. Photographing decorated walls can become the ultimate crutch, and I always hesitate before giving in to these situations.

What dictated the composition of yellow road blocks on the wavy Portuguese sidewalk was a grate that was right next to them. I didn't want it in the image. Angling it out was the starting point in my approach to the subject.

Light

Divine Light! Trip the light fantastic! Lighten up! Not to make light of it, without light there would be no photography.

The possibility of light itself being the subject of a photograph was what lured me into the smelliest possible studio, a community loo. Treading very lightly, I made two enlightened abstractions, one curiously soft-edged, the other hard. Only light helped me transcend this unpleasant environment to reveal its abstract images.

A test for successful abstraction is whether or not the image slips off the paper or out of the slide mount when turned every which way. The vertical photograph was actually shot horizontally. But I feel it's delightful, even when standing on its ear.

Inside a temple in Fatehpur Sikri, India, I became transfixed by the delicate light and shadow from filigree screens. Some were soft-edged and others were sharp, depending on the distance between the actual filigree and its shadow. By underexposing, I achieved the strong silhouette.

Volume

As an exercise in abstraction, I photographed the Ranchos de Taos Church outside Taos, New Mexico, using both wide-angle and telephoto lenses. To the eye, the volumes—or masses—of the adobe structure fell easily into abstract relationships against the blue sky. However, when I looked through the viewfinder, I found that the massive monochromatic shapes resisted being organized into compositions. Finally I realized my mistake: I was trying to force brown matter into compositional submission, rather than looking for the mood of the soft evening light on the adobe. I then wondered how the light created volumes and the illusion of three dimensions, and whether or not the subtle edge lighting provided enough contrast on the adobe. I questioned how my choice of lens would interpret the relationship of volumes. By shifting my awareness, I found an abundance of abstract images.

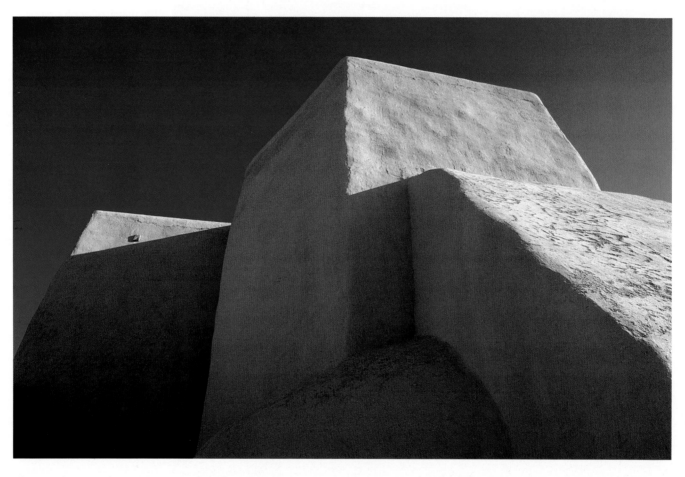

I began photographing the church at Rancho de Taos, New Mexico, by moving off to the left. I wanted to explore the relationship between the shadow area and the backlighted highlights.

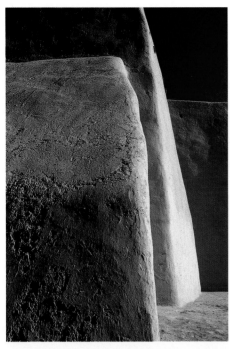

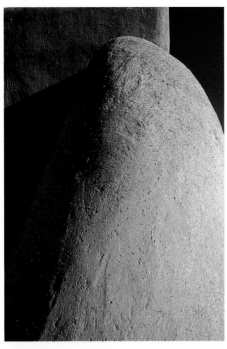

Made of adobe, which is a mixture of earth, water, and straw, the church is rich in organic forms that lend themselves to abstract compositions. These photographs became studies in line and light. There is a natural reluctance to look at shadow areas as a primary investigation. It's much easier to seek out only sunny shots.

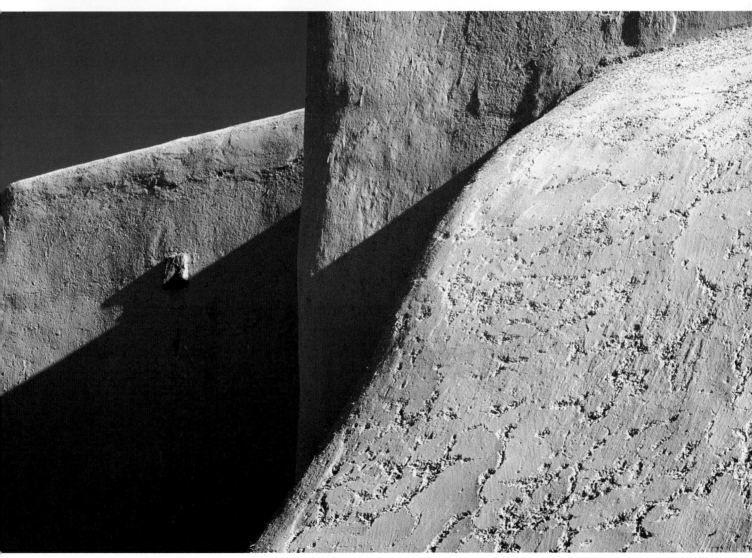

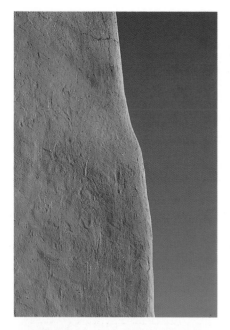

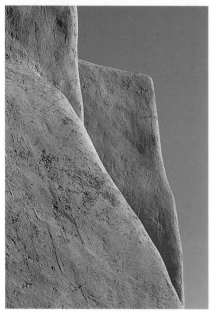

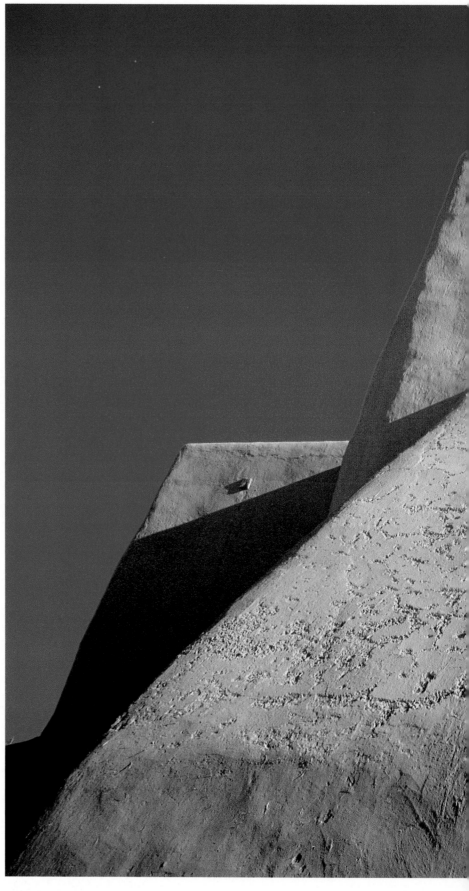

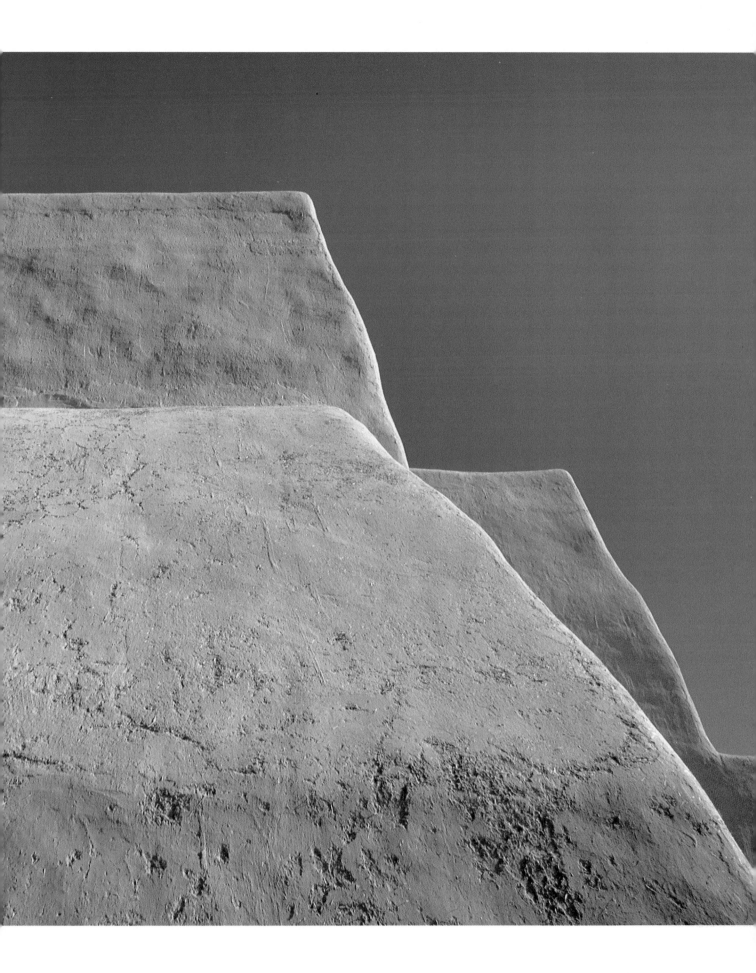

GRAPHIC COLOR

T he organization of color in a photograph plays a vital role in its success as a powerful graphic image. Color combinations greatly influence a photograph's emotional tone.

Any color, or chroma, can be defined in terms of value, that is its relative brightness or lightness and saturation, its degree of purity relative to the three undiluted primary colors: yellow, red, and blue. Light and dark values in a picture create the vital "push-pull" that engages the eye. Dark areas pull it into the image, while light areas push it away, producing visual tension. A saturated color, which "pops" out, works best when set off against an unsaturated or pastel shade.

Warm colors, such as red, yellow, and orange, advance toward the eye in the picture, while cool colors, such as blue, violet, and blue-green, recede. People associate warm colors with energy, danger, and passion, and cool colors with passivity, mystery, and withdrawal. Green, green-yellow, magenta, gray, and brown are more neutral and less distracting.

When combining colors, be aware that using harmonious hues together creates unity, while mixing complementary colors heightens tension. One way to draw attention to a color is to contrast it with its complement. For example, a small amount of yellow assumes more importance in the presence of a large purple area.

Although graphic pictures often rely on bold, vivid colors to draw the eye's attention and make a design statement, there are really no hard and fast rules for using color in a graphic way. Your best approach is to be sensitive to the impact color can have, and then to let your imagination run free.

Balancing Colors

The narrower one's graphic point of view, the trickier it is to balance form, content, and color. With tight graphic images, where subject matter might be minimal, it's easy to make color-for-color's-sake compositions. In both these photographs of drying laundry, the form, or shapes of the color, is arranged from the edges inward, giving an abstract impression.

I like the color proportions in both, and the interaction and distribution of the color. While the blue skirt in the middle of the yellow spreads may be more balanced, colorwise, I prefer the photograph with the skirt at the bottom: the hole plays an important role, and the light on the pleats adds texture that is missing in the other.

The content of both is laundry, of course, and as such, the idea of the image is not momentous. But color, too, is content, and so color is the subject here.

People tell me I "paint" with a camera. Sometimes I wish I could. But when the world presents ready-made canvases such as these, I'm quite satisfied with the medium of photography.

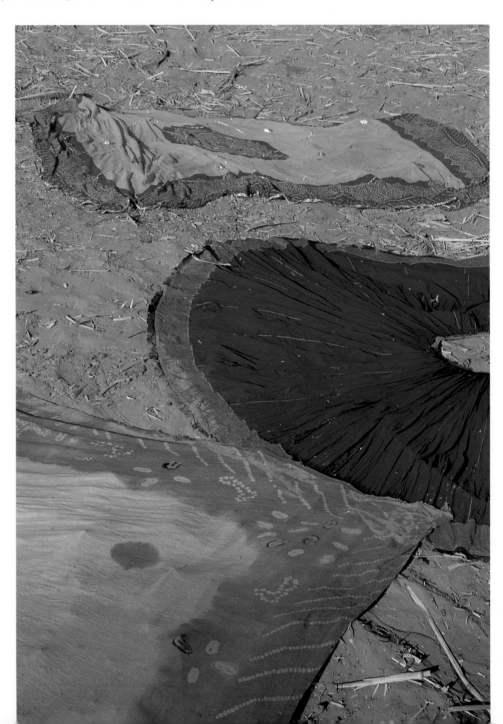

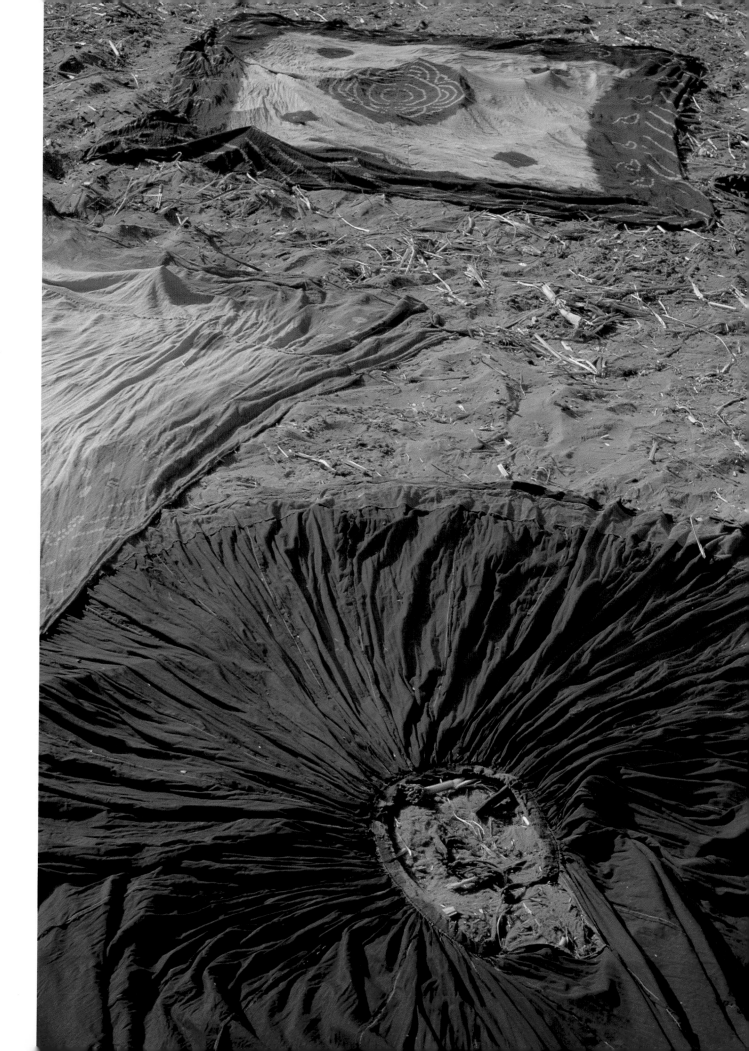

Monochromatic

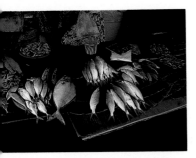

As a color schizophrenic, I love the screaming primary colors in photographs, as well as the whispering earth tones; I'm pulled from one to the other. Once I spied these fish for sale in Indonesia, there was no way I was going to get past these silvery blue colors against the green leaves without exposing film.

Spotting monochromatic picture possibilities might seem more difficult than recognizing the possibilities in the high-keyed hues that leap out at you, demanding attention. But the same principles that demand the balancing of form, content, and color apply to quiet compositions. When I begin to become aware that loud colors are a tempting crutch and my work with them is becoming facile, I force myself to search for monochromatic subjects. While organizing elements in the viewfinder, I mentally eliminate color altogether and work with the pure forms of the subject. I did this exercise with the fish, and I think both formats work well.

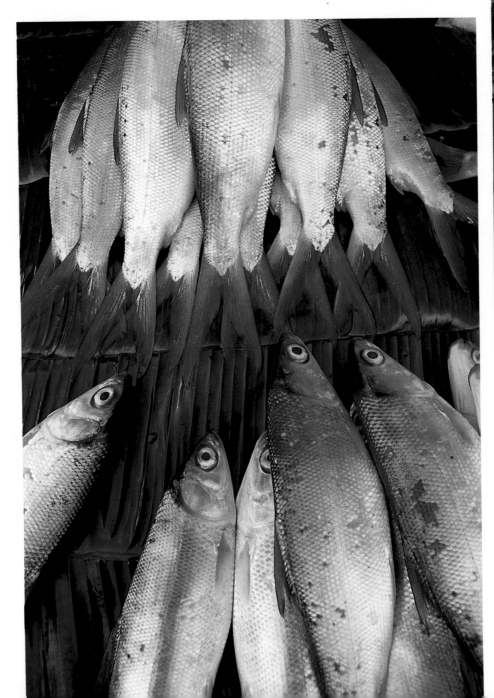

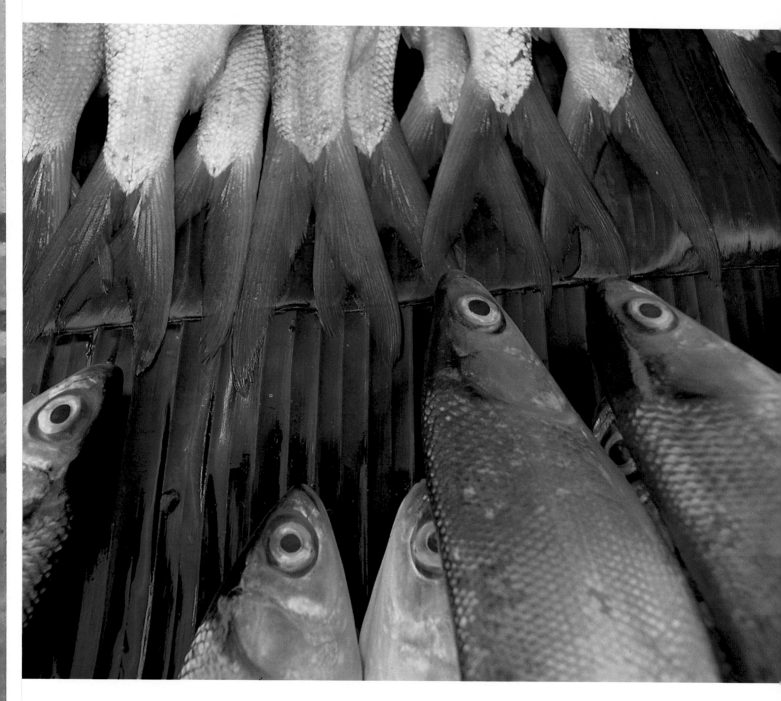

It was the beauty of the palm leaves beneath the fish that drew me to this situation. It's typical of Indonesia to utilize natural materials in all sorts of practical ways. I always look for the ways in which cultures express themselves in everyday life.

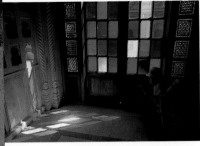

Spectral Hues

A "loud" spectrum, such as the one resulting from sunlight filtering through the stained glass windows, brings to mind the formal issues of color theory. These spectrum images made in India are studies in volume, value, and saturation.

By "volume" I mean the manner in which color occupies space as a quality, and how it supports the illusion of three dimensions in an image. Though the spectrum lies flat on the surfaces in these photographs, there is a dimensional impression created by wide-angle distortion and by the changing values of color.

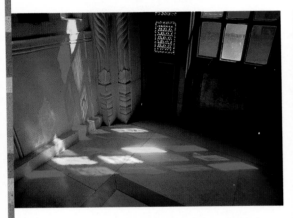

This "gestalt" stained-glass reflection invited several colorful compositions. The horizontal photograph records the situation. The two verticals distort and interpret the reflection more creatively.

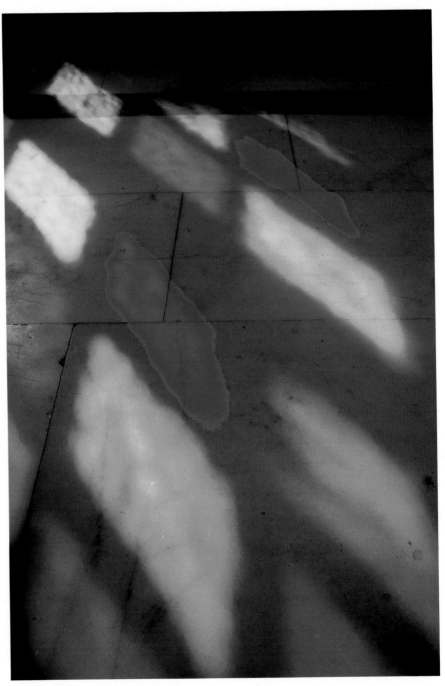

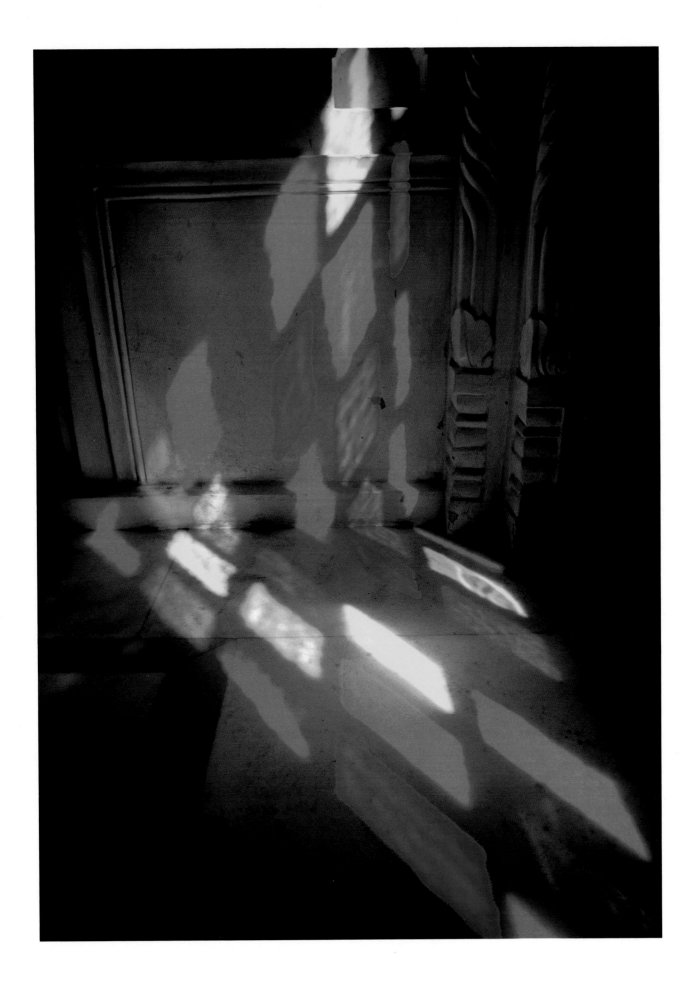

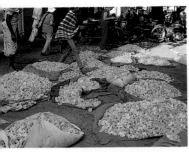

Color Proportion

Color harmony comes through the skillful interaction and distribution of colors. Every color photograph taken requires that the photographer be as keenly aware of chromatic order as a painter is. If this awareness is not instinctual, it must become a conscious process of ordering color in the viewfinder according to feel and flow. One way to develop this awareness is to spend time with intensely colorful situations, as I did at an Indian flower market, where, by burying myself in bags of marigolds, the photographs became studies in color proportion. You can follow the refinement of the compositions, some of which I manipulated. The color harmony, especially in the brown and yellow images, induces a strong emotional reaction: a tension between revealed lightness and covert darkness.

My first shot of the marigold market is the least resolved, from a graphic standpoint. This isn't unusual. Sometimes it can take a few frames to ease into a situation. In this case, I tiptoed photographically at first, wanting to make sure I didn't interfere with the flower commerce. In the second photograph, the three marigolds arranged on the brown cloth tie the two planes of color together. The purple-tied bundle revealing the slits of golden blossoms is one of my favorite photographs.

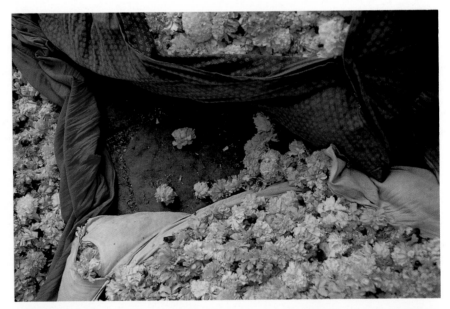

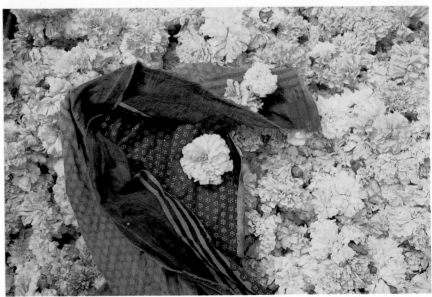

126

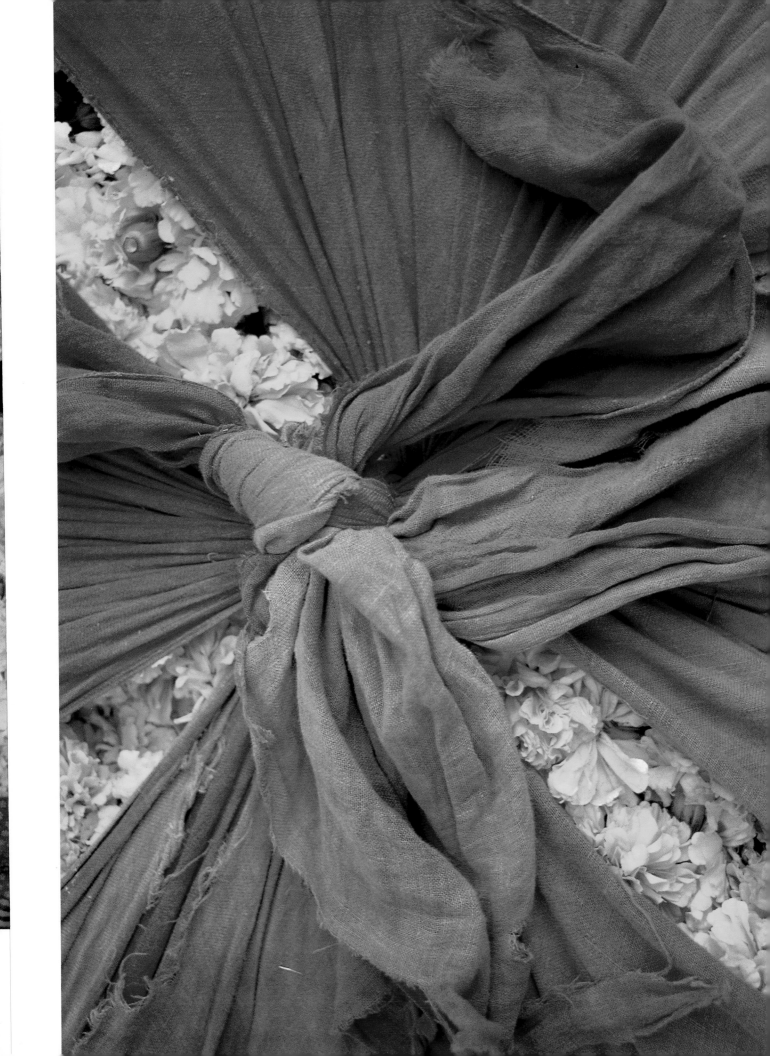

TAKING CONTROL

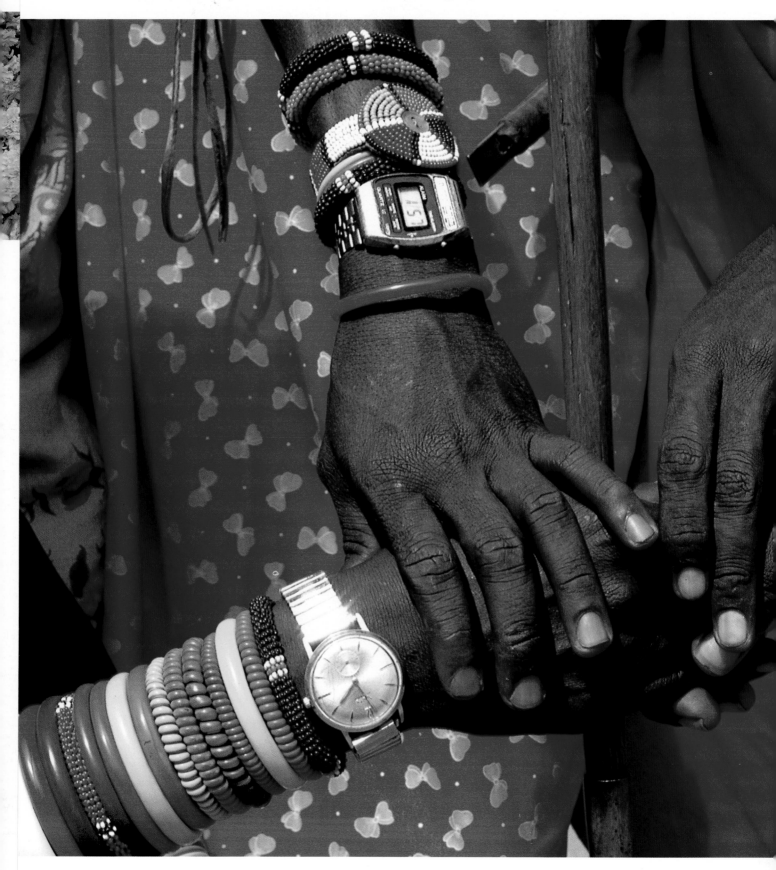

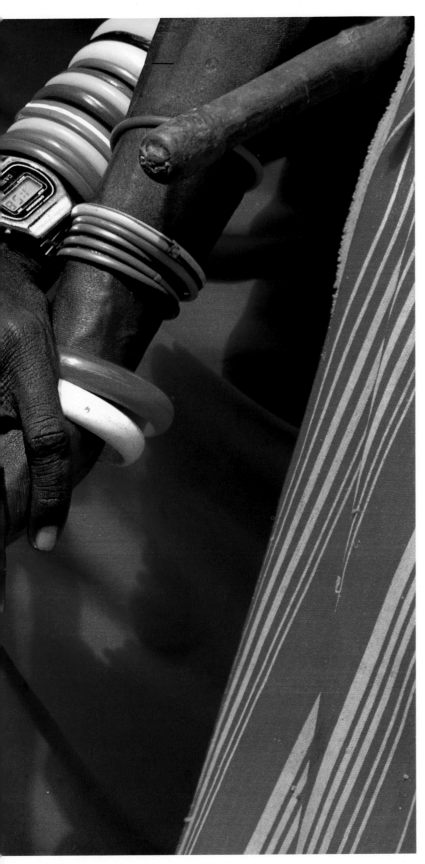

To take photographic control is to take charge, to set the stage for your photograph. Taking control is not always possible in the life of a photographer, but a practiced ability to do so should be readily at hand, as accessible as the ability to change film.

When we take control of our subjects, we are not only picture takers but image creators. We are producers and directors of what we record, and the graphic qualities of our work are heightened.

As we feel the freedom to change things, to arrange what we see, to impose our vision on a world of raw material, we also realize that we are at risk. No longer can we blame the world of "what is" for our shortcomings. But practice, I have found, turns these risky, sometimes seemingly manipulative ventures into successes.

Taking this photographic risk is what builds confidence. Then comes authority, when the "posed" photograph takes on the air of inevitability and sometimes an unexpectedly spontaneous quality.

Why? Because among countless probable arrangements, what genuinely feels right to the photographer has been chosen. Those choices are correct. You like them. The photographs reflect that and the viewer in kind.

No other art reproduces life exactly as we find it. Why should ours?

Your firm, fluid control of your subject matter is, perhaps, the finest, and bravest, gift you can bestow upon your work. It creates a special bond between you and the photograph you have not only captured, but carefully "birthed".

Cultural Symbols

I enjoy making graphic still-life images that reveal my experience of a place. In Jerusalem's Old City, I bought colorful crocheted yarmulkas in a souvenir shop, an obvious cultural symbol to be included in a photograph. A nest of yarmulkas remained in my camera bag for days, while I searched for a spot for a still life image that made sense, environmentally and graphically. Finally, I spread the disks out on my bed at the American Colony Hotel. While studying their colors, I noticed the rug, a perfect setting, right there "at home."

With the camera on a tripod parallel to the floor, I arranged the yarmulkas according to color and volume, in relation to the stripes in the rug. There was enough available light in the room to render good detail in the crochet work, making this image one of my favorite still lifes.

I was delighted to discover that the colors of the yarmulkes I bought were perfect with the rug in my hotel room. It took forever to arrange the crocheted disks on the rug. I even moved the bed and adjusted the rug to get the stripes straight. Inevitably, what looks like a simple shot turns out to be complicated.

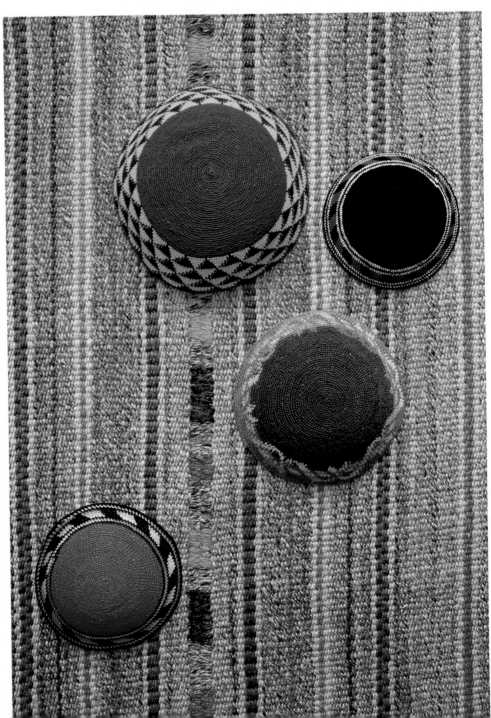

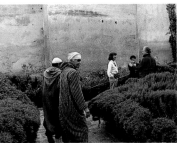

Design Statement

Photographically, I don't believe the world is meant to be taken at face value. Unless you are a photojournalist, there is no reason not to use the world as raw material to make interpretive images that convey your personal reactions to a place.

In Morocco, a guide at the Saadian Tombs in Marrakesh agreed to be photographed in front of a mosaic wall. Placing him there, I first took a frontal portrait, out of politeness and with the knowledge that I was soon going to risk rudeness by asking him to face the wall, wearing his pointed hood on his head. In this way I expected to convey the sense of design in Morocco that is expressed through the relationship between the mosaic rondules, Arabic script, and strong stripes on the burnous. The symmetrical arrangement supports the direct design statement. By taking firm control of the photographic situation, I maximized the graphic potential.

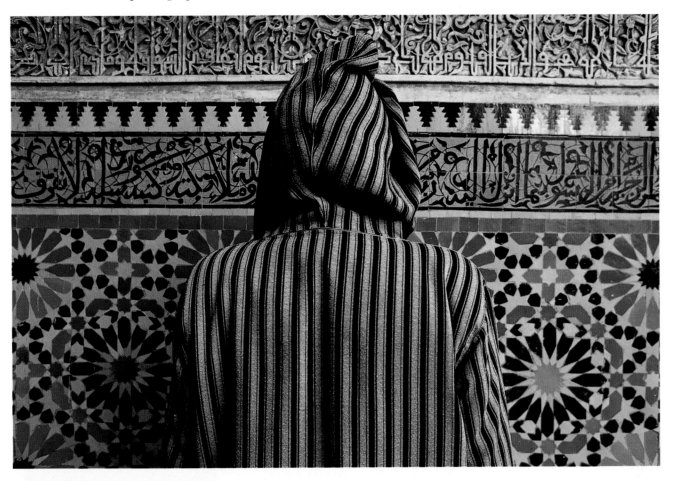

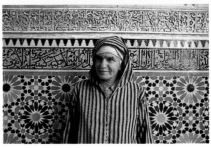

First, I took the shot on the left to be polite. Then I faced the wall myself, to show this Moroccan how I wanted him to pose. He took no offense and willingly complied. All for the sake of art.

133

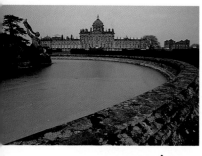

Setting the Stage

Castle Howard is where the TV series "Brideshead Revisited," based on Evelyn Waugh's novel, was filmed. While there with my husband, Landt, one foggy winter morning, I struggled to photograph the stately home from the frozen fountain in the garden below, but I found I was getting only pleasant "recording" shots. Frustrated, I stopped to watch riders canter past an obelisk on the far hill, and then watched the bodiless black heads of a thousand geese punctuating a thick mist over the fields. There wasn't a tourist in sight, and nobody home at the castle.

Seeing Landt sitting on the fountain wall in his new burr-proof tweed jacket, the picture of the English country gentleman, broke the spell. I used his torso to imaginatively recreate, not a portrait, but what I felt about Castle Howard in a symbol that interpreted the English country atmosphere. This is photographic treatment frequently used in fashion photography to establish a sense of place.

Come, everyone! Lady Marchmain is serving tea in the Belvedere.

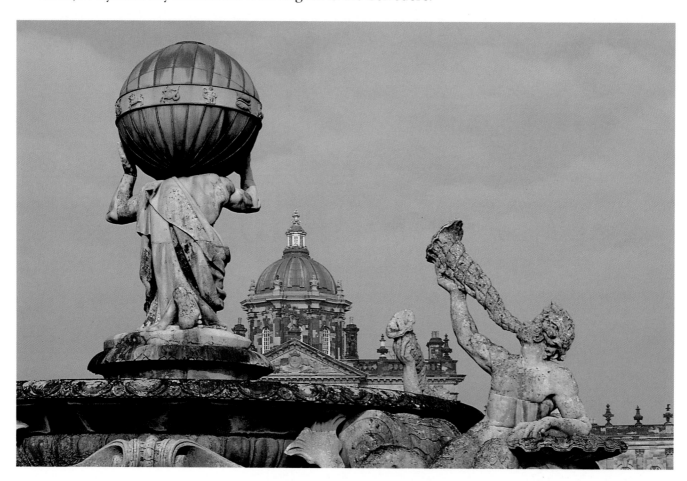

On a gray day at England's Castle Howard, I played with various focal lengths to establish form. Lacking sunlight to create more contrast, I made use of distortion and silhouette. While the photograph of the fountain sculpture and dome represents a classical approach to the subject, it doesn't send me into orbit. My favorite composition is of my husband's torso (following spread).

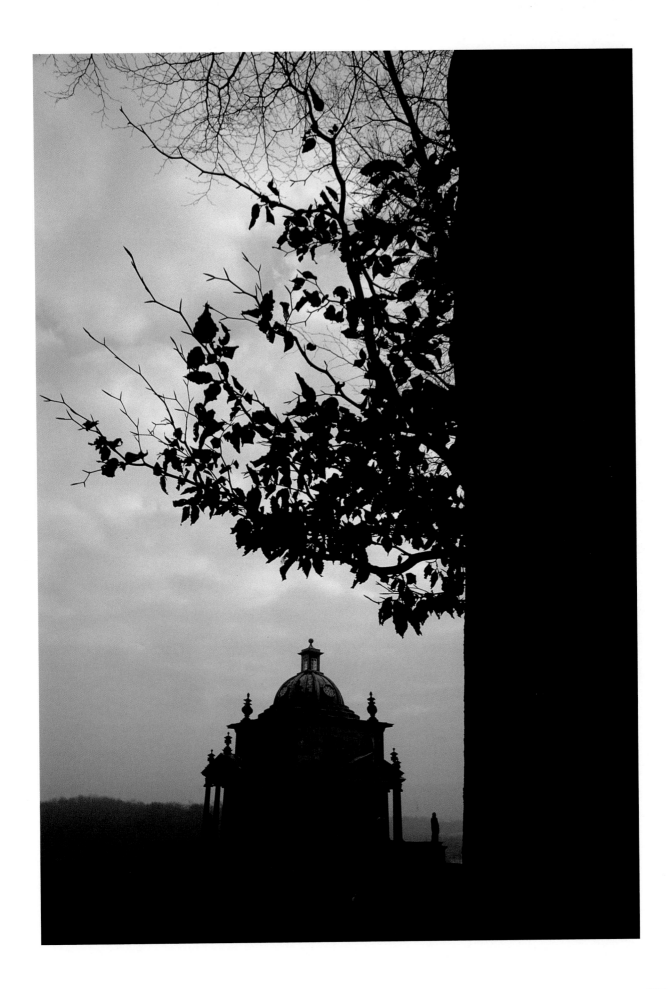

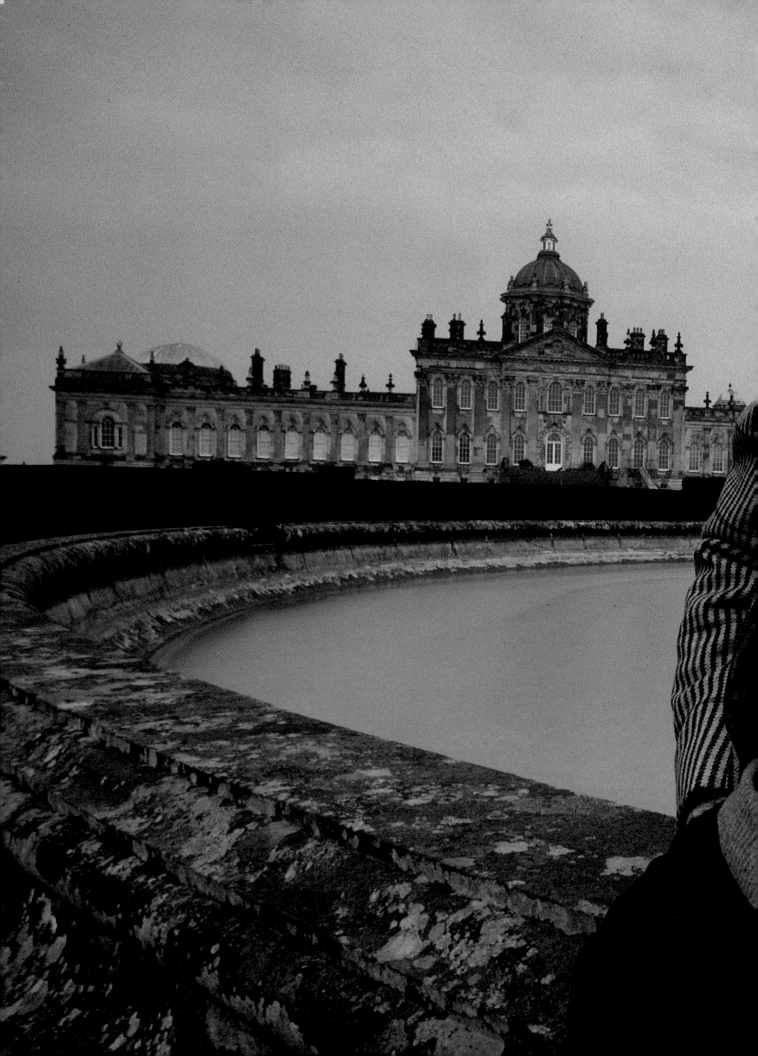

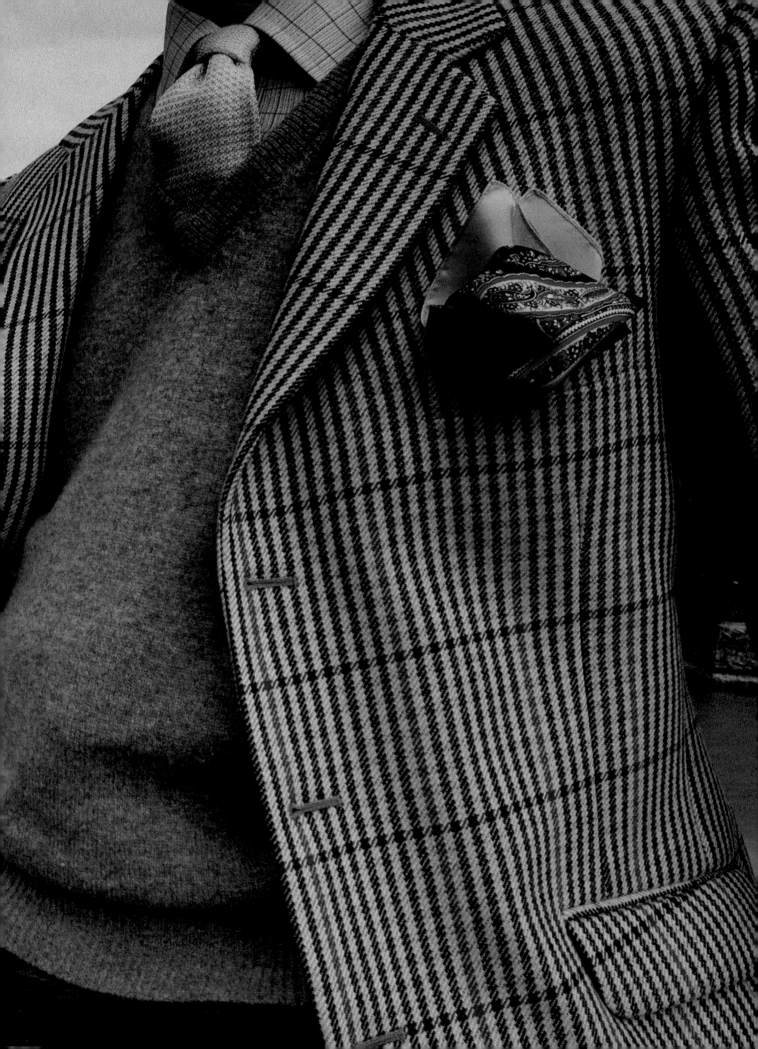

Creating Relationships

Many photographers want to be creators of images, and not just picture takers. I find it infinitely satisfying to direct, produce, and shoot the images that well up within me. Feeling free to do so, I'm not as limited by the intractable material. If you'll give your photographic imagination a whirl, you will derive the same satisfaction from your work.

As a final example, I was photographing the Palace of the Winds in Jaipur, India, the Pink City, from a roof across the street. These spreads were hanging on a clothes line. I thought "why not put them on the wall?" Like magic, an exquisite relationship of oriental pattern transformed my photographs as I moved in closer.

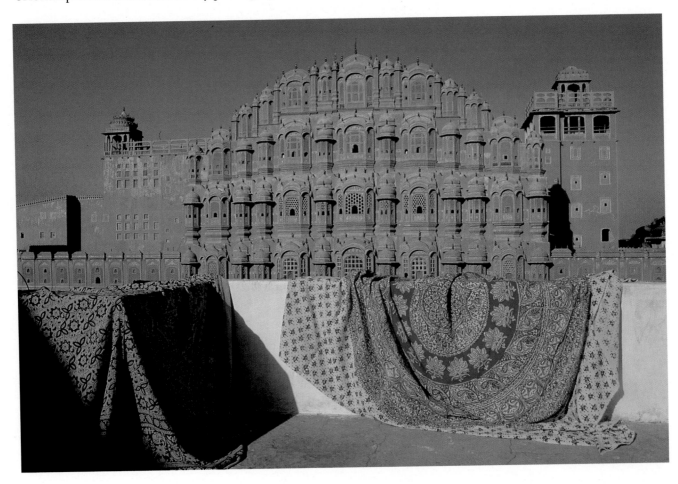

I began by taking shots of both spreads on the wall. Then the whirling relationship of pattern between the spread on the right and Jaipur's Palace of the Winds caught my eye. The vertical image is a better cultural interpretation, as well as being a finer photograph.

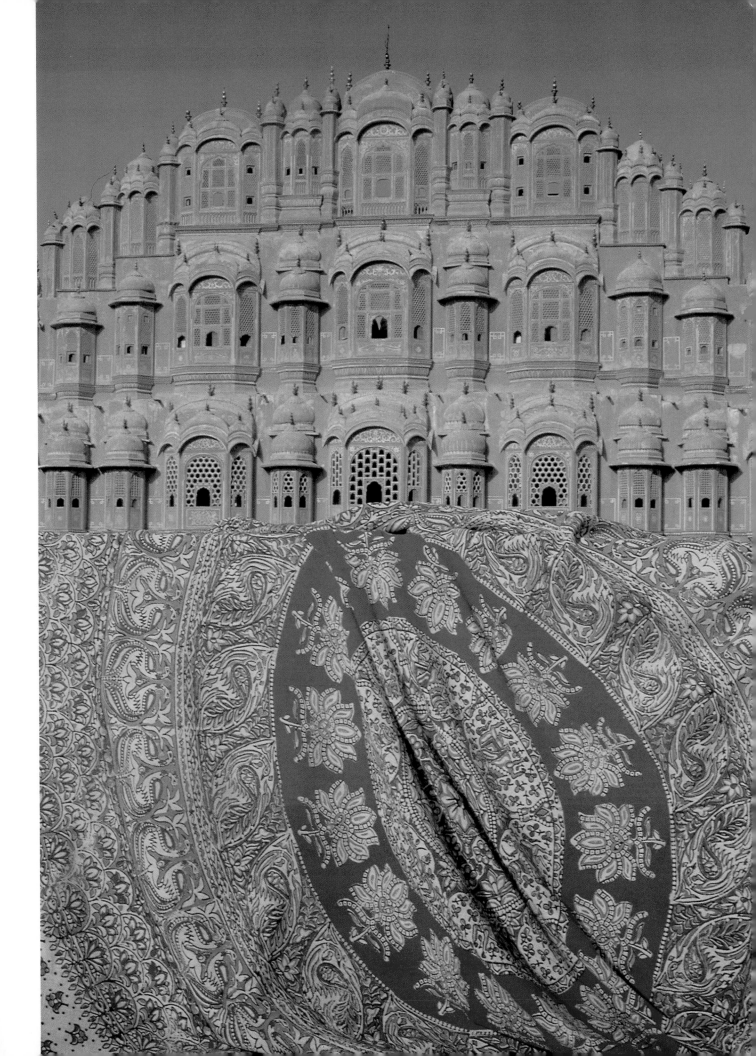

Having a Ball

Commedia dell'Arte comes alive every February with the Carnevale a Venezia, which is the revival of the popular 18th century pre-Lenten letting off of steam. Today the carnival is an open-air masquerade ball with a cast of characters from all over Europe dressed as lords, ladies, mimes, Casanovas, Pantalones, Harlequins, and Pulchinellas. My husband and I have enjoyed the celebration three times, and have our masks safely stored at the Cipriani Hotel for our return on the next carnival photo tour.

Last time, I carried the masks along when visiting Venetian museums, knowing that I would find the wonderfully graphic intaglio floors typical of Italian historic buildings.

Recently, the carnival has revitalized the art of classic mask making, and has encouraged the modern versions worn by the international youth carousing all night long in the Piazza San Marco. Photographing the masks against the floor turned into an ongoing project for me.

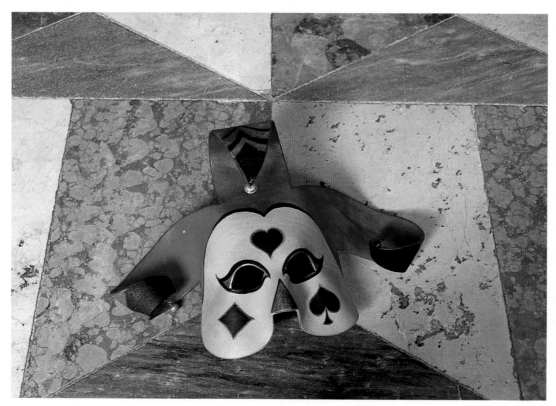

Beginning with a symmetrical composition of the Venetian intaglio floor, I carefully angled the masks in with the graphics and colors of the background. In the picture on the right, the issue was the placement of the ribbons. One millimeter in arranging the minutiae of elements can make or break a composition. Sometimes, if I feel I've been off by even a hair, I'll throw a shot away.

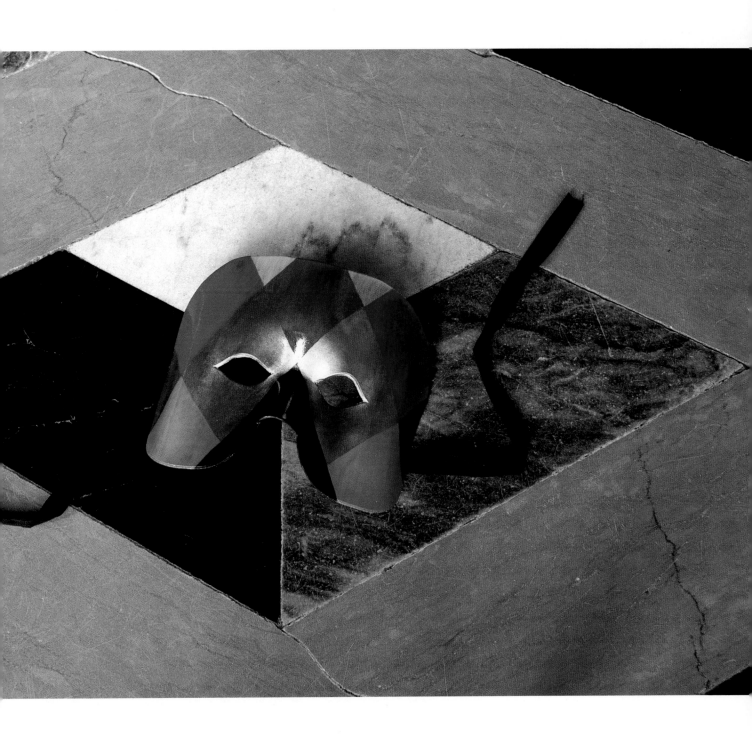

Recreating Experience

Once when my assistant was with me on an assignment for *Architectural Digest* in Jamaica, he returned from his swim with his shoes full of sea urchin shells. Although it was a great sight, I didn't see at first its graphic still-life possibility. He put the sea urchins on a porch table.

One afternoon, I kicked off my espadrilles on the straw mat and sat rocking in a chair. Suddenly I realized that I could translate the table full of shells into an island still-life image. I had bought espadrilles in several colors and determined then that the raspberry ones were most effective when placed on straw.

Filling the espadrilles with the shells, I arranged them in a vertical format to include the base of the rocker. I left lots of space around the shoes, feeling that the straw mat worked to establish an island feeling, and harmonized well with the granulated texture of the shells.

The origins of graphic images are all around us, waiting to be discovered through observation and imagination.

The sea urchin shells were sitting on the table for a couple of days before it dawned on me to make this Jamaican still life. The base of the rocker holds the upper right corner of the composition and helps establish a sense of relaxation.

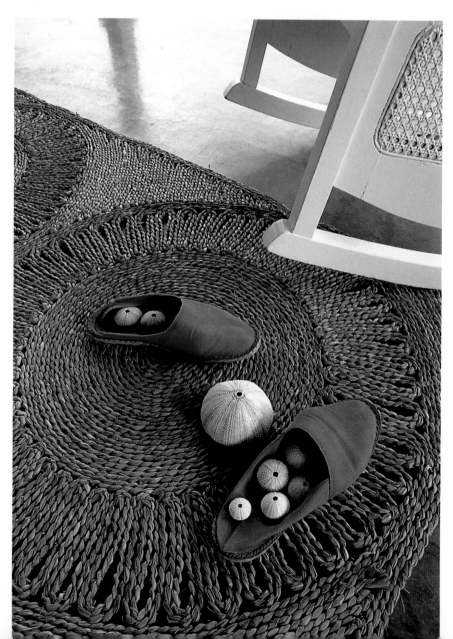

142

INDEX